THE CARE AND REPAIR OF ANTIQUES

The Care and Repair of Antiques

Jacqueline Ridley

illustrated by
David Dowland and Joyce Smith

BLANDFORD PRESS
POOLE DORSET

First published 1978
by Blandford Press Ltd,
Link House, West Street, Poole,
Dorset BH15 1LL

Reprinted 1980

Text and Illustrative content
© Jacqueline Ridley 1978

ISBN 0 7137 0867 0

Colour printed in Great Britain by Sackville Press Ltd, Billericay
Text printed and books bound by Butler & Tanner Ltd, Frome and London

Contents

To Sir with love

Author's Note

This book is intended to help and inform all those who love antiques and works of art. I hope it will enable them not only to make good any damage, but to ensure that the objects in their care do not deteriorate.

Over the years I have had numerous requests for advice from people who have antiques they cherish which have somehow become damaged. They cannot justify the cost of professional restoration; nevertheless they would like their antique to be repaired but do not know how to go about it.

Although there are a number of excellent books aimed at the professional restorer few have been written for the collector who wishes to carry out the repairs himself. I hope that this book has now filled the gap. It may also be of use in some small way to museums which do not have the benefit of the services of a professional conservator.

Before tackling any of the repairs outlined in this book read it carefully, and then read it again. Only when you are confident that you can carry out a particular operation should you attempt to do so. Even then, practise on something worthless beforehand. However, before even contemplating a repair you should ensure that you have an accurate idea of the age and value of the item to be repaired. If valuable it is advisable, if at all possible, to take it to a professional restorer.

Once you have decided to go ahead with the repair, proceed with caution and care, making sure that you refer to the Appendices at the back of the book, following the steps shown in the colour plates.

Introduction

There is more to collecting antiques than the acquiring of objects. Most collectors are proud of their collections and justly so, but few realise that the very objects that they cherish are slowly but surely deteriorating in their care. This is primarily through no fault of their own. Antiques, by their very nature, are in a continual state of deterioration; however, through lack of knowledge of methods of correct display, storage and cleaning, this deterioration is often drastically accelerated.

Antiques in a museum are theoretically in the best possible environment. A museum usually has the resources to create an artificial environment beneficial to the objects and to maintain an equilibrium. This entails controlling the temperature, humidity, light and protecting the objects from harmful dust and gases which may pollute the atmosphere. Apart from this being extremely expensive, it is obviously impractical to create such an environment in the home. However, with knowledge of the principles involved, it is possible with a little forethought and ingenuity to create an environment beneficial to antiques.

Each object reacts differently to its environment depending upon the material from which it is made and its previous history, i.e. whether it has been maltreated or damaged. The best environment is a compromise—one that does least harm to everything, such an environment is equally beneficial to modern objects, especially furniture.

Most collectors are blissfully unaware of what is slowly happening to their collection and what can be done to help. Apart from

9

the care of his collection there are many things the collector can do to improve and enhance the appearance of objects in his care. What should be the guide word throughout is *caution*, and the key word to success is *commonsense*. Many objects that have suffered from the ravages of climate or man can be repaired and restored. Most of the processes involved are simple and can be carried out by anyone after giving the problem a little thought.

At first the collector should concentrate on simple processes. He should not be too ambitious. Processes that look simple may in fact require great skill. Many techniques used in museum laboratories can, however, be adapted for use in the home, using readily available tools and materials. The tools for many of the operations may be found in the kitchen or in the handyman's tool box. Few pieces of apparatus and tools of a specialist nature are necessary and those that are are readily obtainable. Most chemicals are generally available and can be purchased from the average pharmacy.

It is possible to buy antiques, usually at lower prices, that have in some way been badly treated and neglected. Some, and only some, can be improved by simple processes which can be carried out with little difficulty. Knowledge of the materials and technology of antiques can also help the collector guard against fakes.

The simplest precaution the collector can take to guard his possessions against deterioration is to think carefully where he places them in his home. Remembering that light, heat, cold and humidity all affect objects, he should ensure that the areas he uses to display his antiques and works of art should not be badly affected by excesses of any of these. A little time taken in thought on this will often save hours of toil in repair and restoration.

The worst enemies in the modern home are the heating systems. Central heating can often badly damage furniture, paintings and ivory etc. if not watched. Sunlight too can ruin furniture, paintings, prints and embroideries and play some surprising tricks on ivory. It should be obvious that one does not place a valuable piece of antique furniture beside a radiator nor suspend a fine oil paint-

ing above it. It should be equally obvious that one should not hang a delicate watercolour on a wall subject to intense rays of sunlight or place a table in the bay of a window that may have rays of sunlight and shadows. In the latter, one is liable to end up with a striped effect and in the former, a painting which bears little resemblance to the brilliance or perhaps the subtle tones of the original. In the case of paintings it is at the moment impossible to reverse the process. The collector is therefore wise to take precautions against damage to his collection from light. This can occur not only in respect of the fading and other changes in the colour of an object, but in a deterioration of the material of which the object is composed. This is likely to affect the vast majority of works of art including watercolours, prints, scrolls, embroideries, tapestries, costumes, ivory, bone and furniture. In the case of watercolours, it is unfortunate that the fading of colours from exposure to light does not occur uniformly overall, but is likely to affect particular pigments used in the mixing of different colours and their fading can cause peculiar effects. The paper of watercolours, prints and drawings can become yellowed and brittle when exposed to light. Silk in particular is deteriorated by light and becomes brittle and powdery. Wool, cotton and linen are also deteriorated in the same way, yet not quite so badly. Ivory, bone and wood are also bleached by direct sunlight and the heat can dry them and cause irrevocable cracking and warping.

It is important to note that any kind of light can cause the damage mentioned above. If the light is strong, damage will occur quickly, but weaker light will result in the same amount of damage but over a longer period. The effects of sunlight are due more to its strength than anything it contains, for assuming the amounts of light are the same the light from a blue sky can cause more damage than direct sunlight. So, generally speaking, the bluer the light the greater the damage, and the relatively reddish light from an ordinary light bulb is likely to cause less damage than daylight of the same strength. Fluorescent lighting is more dangerous than ordinary light bulbs, and if it must be used it is safer to choose the warmer type of tube. It goes without saying

that if a little thought is giving to the placing of sensitive objects in a room, much of the harmful effects of light can be avoided. Protection from light is relatively easy but protection from the effects of modern heating systems is more difficult and sometimes quite complex. The collector should invest in a wet and dry bulb thermometer or hygrometer so that he can plot the temperature and humidity changes over a period of months. With experimentation he will probably find that areas of his home or even certain areas of rooms maintain a more even humidity and temperature than others. These should prove the best areas for his collection. It does not mean that the other areas should not be used, simply that he must be selective as to what he places there or change the environment. This can be done by employing humidifiers (sometimes just a bowl of water near a radiator) and/or thermostats to ensure a constant temperature. Direct radiant heat can do great damage, as can drastic changes in temperature. The dial type of hygrometer is probably the best type for the collector. This is a simple instrument which can be placed in confined spaces. It gives simple readings which can be readily understood. Unfortunately it has a relatively slow response to rapid changes in the moisture content of the atmosphere.

The sling type of hygrometer is more accurate, this type consists of wet and dry bulb thermometers fixed side by side in a frame which can be swung. The wet bulb is kept damp by a wick dipped into a reservoir of distilled water. The relative humidity can be obtained by reading the difference between the two temperatures and consulting a hygrometic table. For accurate results readings should be taken regularly at the same time and place. Apart from daytime readings, it is also advisable to take readings at night, for the relative humidity of the atmosphere of a closed room can reverse with a fall of temperature. This can be most noticeable when a heating appliance is switched off.

If possible, the collector is advised to try to obtain a relative humidity of approximately 55% at 18 °C (65 °F). The best environment for paintings is 58% relative humidity at 17 °C (63 °F). The safety limits are roughly between 50% and 65%. These are,

of course, ideals and it should be realised that it may be somewhat uncomfortable to sit in a room at 18 °C (65 °F), but as living-room temperatures are a matter of personal choice, the collector should try to arrange the best environment for his collections within these bounds.

As I said earlier commonsense is the key word. Unfortunately it is amazing how few people use it, especially when caring for antiques. One often sees the results of these tragedies when they are brought in for a 'miracle cure'. Some of these are tragedies indeed, like, for instance, the 17th century Dutch ivory box with painted lid which had been cleaned with a scouring pad or the 18th century English watercolour which had been cleaned in the sink with water. Both are perfect examples of lack of thought. Unfortunately this is not confined to private collections; for instance, I know of an oil painting in a museum which was 'cleaned' with household scouring powder! Needless to say it is no longer on display.

A little thought not only about cleaning but also about storage will help avoid such tragedies and will in time greatly enhance the value of a collection.

1 *Pottery and Porcelain*

Fired clay is one of the most stable materials known, even rivalling gold, being resistant to water and chemical actions, its adaptability is unending. Its use for vessels for food and water, building materials, religious representations, writing tablets, funerary vessels and decorations and works of art has provided a medium for the artistic outlet for all the world's civilisations.

The adaptability of clay is unending for the same material can produce many different results, depending on its treatment. The finished result, and to a great extent its future stability, will depend on the temperature and the length of firing, whether or not this was exposed to the air, and various external processes such as burnishing before firing and the addition of various slips (aqueous suspension of a different kind of clay), and glazes. Future stability will also depend on the efficiency of all these processes.

Pottery covered with a vitreous waterproof coating or glaze is more protected than its unglazed counterparts, provided that this coating is perfect. Unglazed pottery is far more vulnerable to external influences such as changes in temperature and humidity, which can cause minute 'hair' cracks to appear in the body. Antiquities are particularly vulnerable in this respect and so a constant, stable environment is essential.

Salting

'Salting' is a problem that affects both pottery and porcelain, glazed and unglazed wares, and also stone, particularly marble. In extreme cases it can completely destroy the surface of an object,

taking detail and decoration from pottery, glaze from porcelain and patina from stone. Egyptian pottery and stone are particularly vulnerable, and the author has seen several fine Egyptian pottery vessels reduced to dust by the prolonged and unchecked action of 'salting'.

'Salting' is a term used to describe the presence of salts, both soluble and insoluble, expanding in the body of an object, which tend to crystallise and accumulate on the surface, causing this to break up as it does so. In extreme cases 'salting' is recognised by salt crystals on the surface, but in less severe cases by a white powdery deposit on the surface.

Treatment is undertaken by washing the salts out of the body of the object, but it is essential to ensure that, if the surface is flaking and liable to be lost during this process, it be consolidated before the salts are removed. This is done by making a solution of polyvinyl alcohol powder in warm distilled water, until a syrupy solution is achieved. This is then strained to remove any lumps and carefully applied to the flaking areas with a brush, holding any flakes in position. When dry it will retain the flakes, yet at the same time allow the soluble salts in solution to pass through and out of the object.

Having consolidated the surface, removal of the soluble salts can take place. On small, robust articles, such as porcelain figures, tiles, plates, etc., this can be achieved by placing the object in a plastic container, and slowly adding a little distilled water. The water should not be allowed to cover the object, but should be enough to be absorbed into it. When this has been absorbed, more water is added. The object should not be submerged, but some surface should be exposed so that any air insde can escape without damage to the object. This distilled water must be changed daily until all the salts have been removed. This can be tested by placing a small amount of the water the object has been soaking in on a spoon held over a flame. When the water has evaporated, there should be no salt residue left in the spoon. When this has been achieved the object should be allowed to dry out naturally and not be exposed to heat, sunlight or draughts.

For larger objects, those in fragile condition, pottery not protected by glaze, or antiquities, a slower, safer method must be adopted for removing soluble salts. After consolidating the surface, if necessary, as described above, papier mache or paper pulp is made using uncoloured blotting paper torn into tiny pieces mixed with distilled water. The pulp is then used to cover the object to a thickness of about 1 cm. A thicker layer, supported by string or wire, might be necessary for large objects. This is allowed to dry completely and is then carefully removed, and the process repeated with fresh pulp as many times as is considered necessary. Testing for salt can be achieved as above, having reconstituted the dried blotting paper with distilled water.

When the pulp is applied to an object, the water is absorbed and the soluble salts dissolved, which by capillary action pass out of the object and back into the pulp as it dries out.

Once the salts have been removed and the object is thoroughly dry it might need further consolidation. This is done with the same polyvinyl alcohol solution mentioned above, which can be applied by brush. In the case of smaller objects, these can be placed in a container and the solution added slowly until maximum absorption is achieved. The strength of the solution can be adjusted to give maximum penetration. After removal from the solution, any excess is brushed away and the object allowed to dry naturally. Polyvinyl alcohol can also be used to strengthen the surfaces of objects that do not have the problem of salting.

Repairing Ceramics

Preparations Generally ceramic repairs are of three kinds: (i) those that are undertaken from fragments; (ii) those undertaken to improve the aesthetic appearance of an object, e.g. when an object has parts missing, such as a hand on a figure or a handle on a cup; (iii) those undertaken to improve an old unsightly repair.

Whatever the reason for a repair, it is very important to identify and value the object. If it is of intrinsic or great sentimental value,

its repair is a job for an expert, and the reader is strongly advised to undertake the following only on objects that do not warrant this expense. Valuable experience, which is all important in ceramic restoration, can be obtained by practising on worthless items, such as cups and plates, before tackling an object of more importance.

Before any repair can begin, it is important to ensure that the object and/or fragments are spotlessly clean. If the joins are to be as perfect as possible all dirt, grime, stains and old adhesive must be completely removed. The object should first be washed and degreased with distilled water with a little best-quality liquid detergent added, always taking care not to further damage any break edges. Further degreasing can be carried out with acetone or with a 50-50 solution of white spirit and distilled water with the addition of a teaspoonful of best-quality liquid detergent per half litre of solution, shaken well and applied with cotton-wool swabs.

Any old retouchings not soluble in water can be removed, preferably with water-washable, or if this is not available, a spirit-based paint stripper such as Nitromors, following carefully the manufacturer's instructions, remembering that most paint strippers have a noxious vapour and can damage skin and clothes. If the object has an absorbent body it is important to pre-soak it in distilled water first, for the water will act as a barrier and prevent any stains moving further into the ceramic.

For stubborn stains a solution of one part hydrogen peroxide to three parts of distilled water, with a few drops of ammonia, can be applied to the wet ceramic with cotton-wool swabs, taking care to protect the hands with rubber gloves or use tweezers or forceps. This process can be repeated with new swabs every few hours until the stain is removed, *but always to a pre-soaked object.*

Removing old adhesive can often be a problem as it chemical composition can change over the years. If it is water soluble, swabs of warm, not hot, water repeatedly applied to the area may be enough, but if after a while this has had little effect, swabs of acetone might be effective if the adhesive is a cellulose one such as Durofix. For rubber adhesives, a paint stripper such as Nitromors

will be effective. Old-fashioned shellac can be very difficult to remove, but this can usually be achieved with Nitromors on to a pre-soaked body, but care must be taken as shellac in conjunction with Nitromors can cause a reaction visible as a purplish stain. When the object (or fragments) is thoroughly clean it must be well rinsed in distilled water and allowed to dry naturally.

If rivets are present in old repairs they must be removed. These are invariably difficult to extract and great care and patience is required if the ceramic is not to be damaged further, perhaps irreparably. A fine hack-saw blade is used to cut the rivet in two, making sure that it at no time comes into contact with the ceramic. When this is done, small pliers are needed to carefully position the rivet, without damaging the object, so that it can be pulled out vertically. Moistening the adhesive holding the rivet with distilled water may help at this point. When the rivets have been removed the holes must be cleared of all old adhesive and stains as mentioned above.

Bonding Before gluing together or bonding fragments it is important to make a 'dummy run'. If bonding is to be a success it is vital that the order in which the pieces are to be bonded is worked out before the adhesive is applied. By experimenting, it will become clear the order in which pieces must go together so that none are locked out and unable to be replaced. This will also give some idea of the quality of the joints.

When repairing ceramics the choice of adhesive is very important. There is no one adhesive that is right for all repairs, so the choice can affect the success of the repair. The type of ceramic must be taken into account, i.e. whether soft or hard bodied, and whether or not the repaired object will be handled often or displayed in a case. There is no adhesive on the market that does not tend to yellow with time, which can cause problems later, although some adhesives are better in this respect than others.

For hard-bodied ceramics, such as porcelains, and those that are to be handled frequently, an epoxy resin would be the correct choice. Epoxy resins should be considered permanent, and there-

18

fore used only when the reader feels confident he can work with them, after practising on worthless objects and also with easily removed water-soluble adhesives. The most suitable epoxy resin for general use is the colourless Araldite AY103 with a separate hardener HY956 used in the proportion of 1 to 5, that is 20 parts of hardener to 100 parts of resin, which can be measured with the smallest kitchen measuring spoons. Care must be taken when using these products as they can cause irritations on contact with the skin. Araldite AY103 and hardener HY956 cannot be readily bought but can be supplied by the manufacturers or museum suppliers, unfortunately in fairly large quantities. Another form of Araldite can be easily purchased from do-it-yourself and hardware shops. Supplied in packs containing two small tubes, one resin, the other hardener, and thoroughly mixed in a 50–50 ratio, this type of Araldite is much more convenient, although less efficient, being thicker, less easy to use and yellow in colour, tending to yellow further with time.

Whichever Araldite is used, a little white pigment, titanium dioxide, available from good artists' suppliers, should be mixed with the resin to blend with the body of the ceramic. When the running order has been worked out and the pigment has been ground in, the resin is applied very sparingly to one of the break edges. Care must be taken not to use too much. The edges can then be placed together under light pressure and secured in position with small pieces of transparent sticky tape (already prepared), to maintain this light pressure and the most exact join. Any surplus adhesive must be wiped from the edges with a damp cloth before it can set. A check must be made all along the join, by running the fingernail across the break edge, to ensure that the join is as perfect as possible. Plasticine, that has been prepared beforehand in the correct positions, is very useful for supporting fragments while the adhesive is curing, as is a washing-up bowl filled with clean, fine sand for larger items. Curing will take at least twenty-four hours, considerably longer in the case of the tubed variety, during which time the fragments must not be disturbed.

For softer-bodied ceramics, such as earthenware and terracotta,

a polyvinyl acetate (PVA) emulsion is by far the most suitable. Soluble in water or acetone, polyvinyl acetate emulsion is much easier to use than resins, although it is by no means as strong, but is thoroughly recommended for the inexperienced and for practising.

Polyvinyl acetate emulsion is manufactured under various names and grades and is available in quantity from museum suppliers. However, a wood-working adhesive that is available from any do-it-yourself shop under the name of 'Evo-Stick Resin W', is virtually the same and has the advantage of being readily available in small quantities. Applied sparingly to the absolutely clean break edges and held in place in exactly the same way as the resin described above, its absorption is increased if the break edges are first slightly moistened. If the adhesive becomes too thick it can be diluted slightly with distilled water. Either a paint brush or a stainless steel tool should be used for PVA emulsion as it will corrode other metals.

A dilute form of PVA emulsion can also be used to consolidate the surface of ceramics, although this can result in a certain amount of surface gloss, which can be adjusted slightly by carefully wiping with cotton-wool swabs moistened with acetone.

Dowelling When a broken object is particularly large, e.g. a large porcelain dish broken in two across the middle, or the handle of a large vessel; and where there is likely to be considerable strain on the break edge and the body is of sufficient thickness, dowels may be used. Made of brass or stainless steel the use of dowels with epoxy resin as the adhesive will give a repair considerable strength.

For general purposes dowelling of 3 mm diameter would be adequate. A dental drill with a diamond point will be required, although this can be improvised by the use of a handyman's drill clamped to a bench and adapted with a flexible cable extension and toughened or diamond-pointed bits. If diamond tips are used it will be necessary to introduce water, perhaps under a gently running tap, or the end will quickly be burned off. A box or wash-

ing-up bowl filled with fine clean sand will be of great help in supporting large articles and transparent sticky tape, preferably in a dispenser, or already cut into usable lengths, will be needed as well as the Araldite adhesive mentioned earlier.

Taking a large porcelain plate that is in two pieces, with one break edge across the middle, as an example the thickest part of the plate is selected for insertion of two dowels. Their intended position is marked with a little water-soluble paint (taking care not to allow the paint under the glaze) and the two pieces are placed together so that the exact position of the dowels and the holes to receive them are marked. Then the holes are drilled, probably 3 mm into the ceramic will be enough, and the correct amount of dowelling cut. The positions of the holes and the dowelling are then checked without the adhesive, and any adjustments made.

One half of the plate is then embedded vertically in the sand box with the dowel holes uppermost. The dowels are then bonded into position on this half of the plate, using Araldite AY103 and hardener HY956 with a little kaolin thoroughly mixed in to stiffen the paste and support the dowel. Care must be taken to release any air that may be trapped at the bottom of the hole. Small strips of transparent sticky tape are then attached to this half, so that they can be flapped onto the other half when it is placed in position. Araldite, with a little titanium dioxide thoroughly mixed in, is then applied sparingly to the break edge of the other half of the plate, wiping away any excess with a damp cloth. This half is then positioned on to the other, making sure that the join is as perfect as it can be by testing with the fingernail across the break edge. Once again any surplus from the adjusted break edge is wiped away, and the sticky tape flapped over into position to support the join. The adhesive must be left for at least twenty-four hours, preferably longer, to cure thoroughly before the plate can be touched.

Filling Invariably, after bonding is complete, there will be areas along the break edge, missing pieces or chips, that will need filling

in if the repair is to be complete. It is at this point that all the time and patience spent cleaning and preparing the edges will be rewarded, for they are now clean and ready for filling.

HARD-BODIED CERAMICS Filling hard-bodied ceramics is best undertaken using the same epoxy resin used for bonding, Araldite AY103 and the hardener HY956, which can be subtly tinted to blend with the body of the ceramic. Although any filling will finally be retouched it is helpful to have a filling that blends with the surrounding body, but it should always be a little lighter than the ceramic itself.

For large areas of filling and modelling, it will be necessary to add to the resin and colouring pigments (see below under Retouching) enough kaolin to form a putty that can be rolled like pastry. For smaller chips or shallow areas the putty should not be so stiff. It is therefore a good idea to make a putty for smaller chips and fill those in, and then add more kaolin for the larger areas. For good adhesion when filling larger areas, or those edges that are particularly smooth, a little neat Araldite, i.e. adhesive plus hardener without kaolin, applied to the break edges to receive the filling will give a good adhesion for the putty. Varying sizes of artists' stainless steel spatulas will be of great help for filling. When filling, particularly in the case of rivet holes, it is important to ensure that no air has been trapped, which could cause problems later. It is also important to keep the work as neat and clean as possible and not to overfill an area. Any excess filling, once cured, will take many hours of delicate work to remove. Try also not to underfill too much, which could necessitate making up more resin to refill when the first layer is cured. This is rather wasteful both in materials and time. Minute air bubbles and blemishes may rise to the surface as the resin cures and these will have to be filled in when the resin is completely cured, so it is wise to retain any remaining resin for this purpose. Although its life is limited once mixed with the hardener, this can be extended by storage in a freezer or the freezing compartment of a fridge, although it should not come in contact with food.

When filling large holes or making up large areas it will be necessary to build up the filling in small areas at a time, in which case storage of resin is essential. For straightforward cases, a treble layer of transparent sticky tape, applied to the other side of the area to be filled, will provide an adequate support for the filling to be shaped against, taking care not to trap any air, and first applying neat adhesive to the break edges for greater adhesion. For larger, more complex areas, Plasticine can be used in the same way, dusted first with French chalk to ease removal when the resin has cured. The resin should be built up in layers, taking care to allow each to cure thoroughly before adding another.

Plasticine can also be used most effectively to mould any missing parts such as rim, flowers, petals, simple lug handles, etc., from another part of the object, dusted with French chalk before filling. It is important that the surface of any filling be smooth and even, which can be achieved by wiping a little methylated spirit on the finger, taking care not to flood the surface or remove too much surface resulting in underfilling.

The Araldite putty mentioned above is equally suitable for replacing missing pieces, such as arms and fingers, on hard-bodied ceramics such as porcelain and bone china. It is, however, not suitable for soft-bodied and more porous ceramics (see below). If the item to be replaced is of any size and weight, such as an arm on an average-size porcelain figure, a dowel will need to be used to strengthen the join and will require drilling and fixing as described earlier. In the case of an arm the dowel should extend to just below the knuckles of the hand, or in other words stop before the area where the modelling becomes fine and less support is required.

After the dowel has been bonded into shape, neat Araldite is applied to the break edge to aid adhesion. Araldite putty in the rough shape of an arm is then placed around this, making sure that the dowel is still in the right place and at the correct angle and taking care not to use too much putty. This is then allowed to cure thoroughly. After curing the modelling continues, building up the desired shape in layers, and making sure that there is

no sagging due to the use of too much putty at one time and ensuring that each layer is thoroughly cured before the next is applied. In the case of an arm, when the final layer of putty has been added, that is the arm up to the knuckles of the hand, and has been allowed to set to a rubbery state, tiny pieces of fuse wire of the appropriate thickness, the ends having been dipped in neat Araldite, are inserted to act as dowels on to which the fingers can be modelled. The fingers are built up in layers in the same way as the arm.

Where individual fingers alone are missing, these can often be built up without inserting dowels, using Araldite putty and allowing each layer to cure before another is added. There is a great temptation to use too much putty when modelling fingers, resulting in much difficult and time-consuming rubbing down afterwards. A very tiny instrument such as a dentist's tool will help to keep the filling in perspective.

SOFT-BODIED CERAMICS The Araldite putty mentioned above is not suitable for soft-bodied ceramics such as earthenware and terracotta, although the methods detailed above are the same. Polyfilla, a readily available interior grade cellulose filler, is ideal for this purpose when mixed with distilled water to a smooth, stiff, clay-like paste. It can easily be tinted with pigment, before adding the water, bearing in mind that it dries lighter than it appears when wet. A little of the dry Polyfilla and pigment mixture is put aside and labelled should it be needed for filling in air bubbles or small chips later, when the majority of the filling has been discarded. Again, care should be taken not to overfill, and the surface kept clean and smooth by rubbing with a wet finger.

FINISHING The finishing off of any filling or make-up can take hours and must be perfect. The success of the whole repair will depend on how well it is finished. Where there is a lot of excess filling to be removed, such as around a moulded replacement, a coarse and then fine file can be used, but it is important not to leave grooves that are below what is to be the finished surface. This is then graduated to small pieces of varying grades of 'wet

or dry' silicone carbide paper, for example beginning with grade 320 and finishing with grade 1200, and then finally polishing with Solvol Autosol, a very fine non-scratching abrasive polish marketed as a chrome polish. Any residue of Solvol Autosol can be removed with white spirit.

It is vital during the whole operation that neither files nor wet or dry paper come into contact with the ceramic that surrounds the filling. If this happens, the surrounding ceramic can become scratched and abraided and is hardly noticed until the damage is done. This can be avoided by always working from the filling towards the ceramic and not from the ceramic towards the filling, and only using very small pieces of silicone carbide paper, about the size of a small finger nail, when working near the ceramic.

It may be necessary to fill in any air holes or faults that may become evident during rubbing down. If this is done the new filling must be left to cure before the operation can continue.

As mentioned above, finishing can take many hours of painstaking rubbing down before the surface is perfect. Accuracy can be tested by oblique light or by passing the finger and fingernail over the surface, as work progresses. However, the final test is best achieved by spraying the area (see below under Retouching) with a fairly liquid polyurethane, mixed with a little titanium dioxide. This is easily removed by solvent and will show up even the slightest error, which can then be adjusted.

RETOUCHING From the collector's point of view, working on his ceramics with few facilities at home, the most suitable medium for retouching is a polyurethane. The alternative would be a stoving enamel, such as Paralac made by ICI, but these are somewhat difficult to use and require heat curing between each application. A polyurethane, such as PU11 made by Furniglas, on the other hand, does not need stoving, is cold curing and has the hardness, clearness and non-discolouring properties ideal for use as the medium for ceramic restoration. The solvent for PU11 is Gipgloss Cellulose Thinner. Both polyurethane and solvent are highly inflammable, have a noxious vapour and must be used and stored

with great care, in a well-ventilated room, away from naked flame or heat.

Polyurethane can either be applied with a brush or spray. Brushes need to be the best possible quality sable of varying sizes from 00 to 2, which must always be carefully cleaned with solvent and kept away from dust and other contamination which may mar the retouching.

A spray gun and compressor is a useful piece of equipment, but undoubtedly too expensive for the collector, unless he is going to undertake a lot of ceramic restoration. Most retouching can be done with a brush, but spraying is quicker and comes into its own when larger areas are to be retouched or if a particular finish such as an 'orange peel' effect or graduated colouring is required.

One of the disadvantages with a spray gun is that the retouch may extend over the fill to the glaze. As a general rule this should not be allowed to happen; the retouch, whether applied by brush or spray, should overlap the glaze by only the minutest amount.

Artists' dry pigments, obtainable from good artists' supply shops, are used to colour the polyurethane medium to tone with the surrounding glaze. A fairly comprehensive range will be needed to cover most needs, but this can be built up as required. Artists' dry pigment is usually sold in small containers and the cost can vary depending on the colour, but as so little is used, it will last a long time. A useful range of pigments might be as follows: light red, yellow ochre, chrome yellow, raw sienna, lemon yellow and chrome orange for the yellows; terre verte and viridian for the green; burnt and raw umber for the brown; French ultramarine, Prussian blue and cobalt blue for blue; lamp black for black and titanium dioxide for white.

Although these are fine powders, it is very important that the tiny amounts used are mixed very thoroughly into the medium, or streaking will result. The best tool for mixing in pigments is a small stainless steel spatula with a glass tile or white laminate 'off-cut' as a palette.

When retouching, tools, brushes and hands must be spotlessly clean and free from dust and grease. The environment, too, must

be as dust free as possible to avoid the retouch being spoilt and much valuable time taken in rubbing down. In the case of the polyurethane PU11 medium, only small amounts at a time need be taken from the tin with a clean tool, and the lid firmly replaced. The pigments are then mixed in until the required colour is achieved, the density of the retouch depending on how much pigment is used. Usually more pigment is used for the first one or two coats, this gradually decreasing in the subsequent coats, as a more transparent effect is needed. It must be remembered that the medium will always be darker when dry than when it is being mixed.

Several coats of polyurethane may be necessary to achieve a perfect match to the background glaze, before any decoration can be applied. Ideally each coat should have less pigment than the one before, the last having very little or none at all, as the gloss of the medium is affected by the amount of pigment and will dry matt if overloaded. Each coat must be allowed to dry thoroughly, which will take at least twenty-four hours, before the next is applied. Between each coat the surface is carefully rubbed down with tiny pieces of extremely fine abrasive paper, such as Flex-i-grit, to provide a good foundation for the next coat and correct any discrepancies between retouch and glaze. Always work from the retouch towards the glaze and never the other way. Take great care not to damage the glaze. The area must be degreased by wiping with a cotton-wool swab with a little acetone between each coat.

The retouch should be taken up to the glaze and if necessary to the minutest degree over it, but that is all. The solvent, Gipgloss, can help in this respect by moistening a brush and graduating the medium towards the glaze. Solvent can also be used to thin the medium down, so as not to develop a ridge between retouch and glaze, although this must be done with caution, as too much thinning will result in a matting effect and a tendency not to dry to the required hardness.

Finally, when the retouching is complete and thoroughly dry, it can be given a final polish with the chrome polish Solvol

Autosol which should also eliminate any minute discrepancies that still remain.

For ceramics where a matt rather than glossy effect is required, as in the case of Wedgwood, a matting agent can be added to the medium, the amount of matting agent depending on the degree of mattness required. The best matting agents are TK800 for mediums with no pigment added and HK125 when pigment is used. Unfortunately matting agents are not readily available but can usually be obtained through main artists' suppliers or museum suppliers.

For gilding, the best and most lasting effect is achieved with either gold tablet or gold leaf transfer. Gold tablet, which is gold powder in a water-soluble gum, is by far the easiest to use. Gold leaf transfer, backed as it is with tissue, requires a certain amount of practice. Gold tablet, on the other hand, can be applied with a brush; it can be burnished when set to give a very good finish. Both forms are unfortunately expensive, although the little one gets does at least go a long way.

Other gold preparations are a good deal cheaper, but the effect is not comparable to gold tablet or gold leaf and they are by no means stable, eventually oxidising and going black. This oxidation can, however, be delayed by giving a protective coating of polyurethane when dry.

To achieve a good retouch requires skill, patience and a certain amount of experience, particularly when handling the medium and developing an eye for matching colours. Practise then on worthless items and learn as you go along, before you tackle a piece of greater value. Be sure you know the value of an item before you even contemplate working on it, and if it is of value or great importance consider having the work done professionally.

There is only one criterion when retouching ceramics—perfection. Throughout all the operations involved in filling and retouching, if any one operation is anything less than perfect it just will not do. If you are not prepared to become a perfectionist then you will be wasting your time for two reasons. One, because

each operation must be as good as it can be if the finished job is to be of any standard; and two, if the aesthetic appeal of the object is not enhanced, the retouch is better left undone.

Having said this it does not mean that all retouching should be invisible, in fact most museums prefer it not to be, but should be in keeping with an object and enhance its appearance.

If you are wise and begin by working on worthless items, making mistakes that don't matter and learning from them, ceramic restoration can not only be challenging but fun and will I'm sure give a greater understanding of ceramics and the artists who produced them.

2

Glass

Glass is one of the most difficult of all materials to repair, for once broken it is almost impossible to disguise the break. Although we understand its fragility we quite often fail to appreciate that it is also vulnerable to atmospheric conditions and, which is surprising to many, damp.

The composition of ancient glass is quite different to that of the present day, as is even the glass of the 17th century, which was made from soda or potash, lime and silica. These early glasses are greatly affected by humidity. Roman glass sometimes has a very beautiful surface of pastel pinks, blues and greens with a pearl-like sheen. This iridescence, sought after by collectors, is in fact chemical deterioration.

Modern glass, too, may be affected by damp—a fact that can clearly be demonstrated by the unsightly white 'stains' in decanters. This condition, which cannot be removed, is caused by break-down of the surface of the glass which has been subjected to hyper-humidity. It can happen to a decanter that has been washed but not properly dried, a condition that can easily be avoided by blowing warm air into the interior with a hairdryer.

Not all stains are permanent. Decanters sometimes have wine stains (these may look similar to humidity deterioration). These stains may be removed by cleaning with a dilute solution of 5% nitric or sulphuric acid; *be sure to use rubber gloves*. After treatment the decanter must be rinsed at least ten times with clean water. The decanter should then be inverted and allowed to drain before

drying with a hairdryer. Stains in drinking glasses or flower vases may also be removed in the same manner.

Commercial stain removers are also quite effective. Always read and follow the instructions on the packet carefully.

Another problem that decanters have is that their stoppers tend to get stuck. If this happens do not try to twist the stopper out. Mix a little glycerine with methylated spirit; pour this around the stopper and leave overnight. This should do the trick.

When washing glass, always use warm water, not hot and never boiling. Add a weak detergent. Rinse with tepid or cold water before drying with a soft linen cloth. Always store glass in as dry a condition as possible, ensuring that the cupboard or storeplace has adequate ventilation. It is best not to wrap glass in anything, as most paper is hygroscopic and may retain damp.

Should a tragedy befall your treasured glass bowl or similar object, there is, as was mentioned earlier, little that can be done, save reassemble the pieces. Glass suffers from the fact that it is transparent. When broken the break forms new surfaces which catch and reflect the light like facets in cut-glass—then it is almost impossible to disguise.

Broken glass may be reassembled in a similar way to porcelain. Araldite AY101 and HY956 give acceptable results; if possible, use the American epoxy resin Maraset A655 which does not discolour as much as Araldite. Durofix is also suitable and has the advantage of being able to be removed; it, however, has the disadvantage of lack of strength so that anything repaired with it cannot be used. A similar adhesive may be made by dissolving Perspex in a solution of 195 ml ethylene dichloride and 5 ml glacial acetic acid. The new instant adhesives, i.e. those that cure in 4 to 5 second, have advantages for mending thin intricate pieces that cannot be adequately supported, but they are dangerous and need considerable practice, besides a very steady hand.

Glass suffers from the disadvantage of being very thin and smooth along the broken surfaces. This makes adhesion difficult. Reconstruction of a bowl or similar item may be aided by holding the pieces together from the inside with adhesive tape. Sometimes

it may be possible to reinforce a glass object with fibreglass and resin.

One of the most common disasters to befall stemmed glasses is that the stem tends to break. This is one repair that fortunately can be made successfully. Although the two halves can be joined without a dowel, a dowel is more effective. The following is a brief description of repairing a glass firstly with a glass dowel, then without.

The two halves are first washed and degreased. A dob of paint is applied to one half, then the other is brought into alignment, brought together, then separated. The spots on the two halves mark the place which must be drilled to take the glass dowel. Drilling must be done with a diamond bit as described in the chapter on porcelain (page 20). The bit and the glass must be kept cool by dousing with water.

When there is a hole of sufficient depth each side to accommodate the dowel, the glass should again be washed and degreased and dried. Epoxy resin is mixed, as for porcelain—but without the addition of pigment (page 21). This is applied to the dowel and to one surface of the break. The dowel is inserted and the two halves brought together and kept in position by adhesive tape from base to bowl. Excess adhesive must be removed before it sets, but if any remains it may be removed by a sharp scalpel blade. Glass dowels are available commercially.

Joining without a dowel is more risky. A cradle of Plasticine or similar material must be made to hold the two halves. After degreasing, epoxy resin is applied to one half and the other half brought together, and kept together with adhesive tape. The whole assembly is kept together cradled on the Plasticine, where it should remain until the adhesive has cured.

3 *Stone Sculpture*

Much damage is caused to stone sculpture due to the misguided impression that all stone is tough, resistant and durable. This is not true of any of the stones used for works of art, whether granite, basalt, sandstone, limestone or marble. All have a delicate balance that can be destroyed by physical damage, chemical pollution, heat and cold.

If we can generalise, it may be said that most dressed stone develops a protective skin or patina which gives a certain amount of protection. If this patina is broken, the stone is layed bare for further deterioration to take place. For this reason great care must be taken not to damage, however minutely, stone sculpture that has previously been considered indestructible.

It can also be said that all stone, to a greater or lesser degree, is affected by atmospheric pollution, such as the high level of sulphur acids in city atmospheres, which can cause surface corrosion and deterioration. Sculpture, then, is best kept indoors wherever possible, where pollution is likely to be less and where it can be protected from pollutants carried by rain. If it is not possible to remove sculpture from the open air during the winter months it is best protected by a covering of black polythene. This should also offer some protection against the ravages of frost, particularly to damp or damaged stone. When storing stone sculpture indoors the temperature should be warm and, most of all, constant. Exposure to heat can damage stone sculpture and, in the case of marble, can turn its delicate structure into opaque quicklime, which will virtually crumble away. Smoke from

open fires can have a disfiguring staining action that is very difficult or impossible to remove, depending on the nature of the stone.

Porous stones such as limestone, sandstone and marble are particularly susceptible to 'salting', which is a term used to explain the crystallisation of soluble salts on a porous surface. The symptoms appear when salts present in the stone move towards the surface, where there is greater evaporation, and either take the form of a hard white deposit or crystals on the surface. Once the symptoms are noticed, they must quickly be treated or the surface of the stone can be broken down and much surface detail lost. Treatment is described fully under the chapter 'Pottery and Porcelain'.

Cleaning stone sculpture, and in particular marble, often does more harm than good. In the case of marble, dusting with even the cleanest cloths can result in greasy streaking, so the soft brush-nozzle of a vacuum cleaner covered with soft clean muslin is more efficient. Marble is highly porous and so should never be cleaned with quantities of water, commercial cleaning agents or acids, as these can result in tide marks, staining and surface deterioration, respectively. If necessary, marble is best cleaned with damp, not wet, swabs of cotton wool and a solution of 50% white spirit, 50% water with a teaspoon of good-quality washing-up liquid to every 600 ml of solution. This can be stored in a screw-top bottle and shaken before use. It must be applied sparingly and systematically over small areas at a time, discarding each cotton-wool swab as soon as it becomes soiled, and taking care not to rub any dirt or grit into the surface of the marble.

For marble that is really dirty and shows signs of grease or old varnish or wax, the surface can be degreased using a methylene chloride-based solvent, marketed as paint strippers, the most suitable being water-based Nitromors, in a green can. Care must be taken that this solvent does not come into contact with the skin, which it can burn, and that it is used in good ventilation, preferably out of doors. Each small area must not come into contact with the solvent for more than a moment after which a swab

of acetone must always be applied to the area, and the surface then wiped gently with a clean, dry swab. If there is any deep-seated grime remaining, this can be removed by applying a magnesium silicate mud pack which will have the effect of drawing out the grime as its moisture evaporates. Marketed as Sepiolite (100 mesh grade) and easily obtained from museum suppliers, it is made into a mud pack with distilled water and applied to the sculpture. When thoroughly dry it is carefully picked from the surface which is then wiped down with water. If necessary the process can be repeated.

Removal of stains in marble is difficult to achieve successfully without a knowledge of the nature of the stain. Iron stains cannot be dissolved. Often it is best to leave the stain or camouflage it by careful use of pastels, than to risk a patchy result. Surface blemishes can often be removed by the careful use of a fine polish known as Solvol Autosol, which is easily obtainable from auto suppliers where it is sold as a chrome polish. It is safe if carefully used in small amounts on a colourless clean cloth. The residue is then wiped away with swabs of cotton wool dampened with white spirits. Coloured stains can sometimes be bleached with damp swabs of 20 volumes of hydrogen peroxide with a few drops of ammonia added, but this process is not without hazard and must be used cautiously. Unknown stains should first be tested with the various solvents mentioned above, from water, white spirit to Nitromors, taking care that the solvent does not result in the stain being drawn deeper into the stone.

Marble that is out of doors can be cleaned by spraying with a fine spray of water and gently brushing away dirt or corrosion products. This could take several hours and should be attempted only on sound marble and when there is no danger of frost. Any fungal growths must be killed with a fungicide, such as a 4% aqueous solution of pentachlorophenol (Santobrite), and any stains remaining removed as described above.

Once cleared, the surface of marble can be protected by a mixture of wax and resin, easily obtained under the name of Winton Matt Varnish by the artists' suppliers Winsor and Newton,

and applied with a soft brush, taking care to remove any excess. This varnish, if carefully applied, should not only protect the marble sculpture but also enhance its appearance and can be removed if necessary with white spirit.

4

Metal

More than any other works of art that come under under the scope of this book, those made from metals, diverse though these may be, are particularly susceptible to deterioration from a hostile environment and damage from hostile owners!

A work of art made from metal that is in good condition has a wonderfully subtle bloom and colour that is generally known as patina. The patina should improve with age, enhancing the appearance and therefore the value of a piece. Patina is generally (and sometimes mistakenly) regarded as an indication of age and authenticity. When stable, the patina not only enhances the appearance of a work of art, but also serves as a protection to the underlying metal.

Whether an object was made in AD 1940, 1640, or 1640 BC, the patina, then, is something that must be respected and preserved. Its loss is irreparable and irreversible.

Silver and Silver Plate

Unless it has been buried, there are few problems that confront us in the case of silver, except its tendency to tarnish. This is a thin film of silver sulphide which discolours the surface and is brought about by contact with the atmosphere, which may contain sulphur from industrial and domestic chimneys.

Silver is a surprisingly soft and delicate metal that can easily be scratched and dented. For this reason great care must be taken when cleaning silver items. The cloths used to polish or merely dust, must be absolutely clean and free from dust and grit that

could easily cause scratching. As a general rule, patented silver cleaning powders should not be used, as no matter how fine they may be, they are nevertheless abrasive, and will, at best, wear away a little silver each time they are used. At worst they cause fine scratches.

This can be particularly noticeable in the area of the hallmark, which although free from a tarnish may be worn down on pieces that have been cleaned with powders. The hallmark should be cleaned as little as possible, for a good sharp mark will enhance the interest and value of an item. For general brightening up before use, the impregnated cleaning cloths, available under various names, are very useful.

The least damaging of silver cleaners is the type which comes in liquid form in wide-mouthed jars, and is marketed in the UK by Goddards under the name 'Silver Dip'. Small objects can be attached to a thread and dropped into the jar, or larger pieces can be cleaned with swabs of cotton wool moistened in the liquid. Care must be taken not to expose the silver to the Dip for too long as this could have an adverse effect, especially on silver plate. Just a few seconds will probably be enough. Thorough rinsing is vital, either after the object has been dipped or, if swabs are used, after each small area has been cleaned. Rubber gloves to protect the hands are a wise precaution, and as always when using commercial products, the manufacturer's instructions must be carefully followed. Although Silver Dip can be used to clean other metals, they must not be dipped into the same liquid that has been used for silver. As the Dip works on an electro-chemical principle, other metals could become plated with residue from cleaned silver.

After thoroughly rinsing the object it can be polished with a soft, dust-free cloth. It must be thoroughly dried by leaving it in a warm atmosphere, remembering that tarnishing is accelerated in the presence of moisture.

Although tarnishing is inevitable (unless the object is to be kept under strictly controlled conditions) its return can be delayed by either applying a coat of lacquer such as Ercalene or by a very

sparing coat of microcrystalline wax polish (see Formulae). In both cases the object must first be degreased with cotton-wool swabs of methylated spirit. Wearing gloves to avoid those tell-tale fingermarks, the lacquer can then be applied with a soft brush, taking care that the surface is completely covered with a thin, uniform coat and that the lacquer does not collect in the crevices. When the lacquer becomes streaky, which is usually in about twelve months (but of course depending on conditions), it can be removed with swabs of acetone. Microcrystalline wax is applied very sparingly with a soft, dust-free cloth. To apply too much would be detrimental to the object as this would attract dust which could cause scratching when handled or dusted.

When storing silver, it is important that all traces of moisture are excluded. This can be done by 'airing' both the silver and the packing materials, which can be fresh, acid-free tissue paper or cotton wool, in a warm, dry atmosphere before packing. Provided all traces of moisture have been excluded, self-sealing polythene bags are very useful for storage.

Silica gel crystals are an asset when storing metals, in that they absorb any moisture present, keeping the metal dry. Readily available, the crystals can be put into little muslin bags, just like lavender bags, and incorporated in the packing.

Heavily tarnished silver that will not respond to the 'Silver Dip' method mentioned above can be cleaned by a more elaborate electro-chemical process. An ordinary plastic washing-up bowl is lined at the bottom with a double layer of aluminium foil. The tarnished silver item is then placed on this, making sure that there is a good contact between foil and silver. The silver object is then covered with a 5% solution of washing soda (sodium carbonate) in hot water (i.e. 50 ml of soda per litre of hot water). This solution will effervesce and give off fumes. The silver should be left in this solution for only a few seconds at a time, until the tarnish is removed. It is a good idea, if possible, to attach two pieces of strong nylon cord to the object (not tight enough to impede cleaning, but absolutely secure) to make removal simpler.

It is, however, vital to ensure that there is no inlaid decoration

or enamelling, such as niello ornament, before electro-chemical methods are employed, as any such ornament could be destroyed by the process.

When the tarnish has been satisfactorily removed the object must be thoroughly rinsed in plenty of tepid water, taking care that it does not come into contact with anything that may cause scratching, such as jewellery or the sides of a sink. It can then be dried with cotton wool and polished with a soft, clean cloth, and waxed or lacquered as above.

Copper, Bronze and Brass

Copper and its alloys, i.e. bronze, when mixed with tin; brass, when mixed with zinc, has been used to fashion the ornate and the utilitarian since antiquity.

These metals are more vulnerable than silver, given the same conditions, for copper is affected by oxygen as well as sulphur, which is all too present in our city atmospheres, giving rise very quickly to a dulling film of oxide. This film more than likely affords a certain protection to the underlying metal; however, in the case of copper that has been alloyed and not properly mixed with tin or zinc for example, the oxidised surface can become rather patchy and unsightly.

For copper that needs to be kept clean, such as old copper kettles etc., a commercial cleaner of the impregnated-cloth variety will usually remove the oxide. Care must be taken not to use abrasive polishes, or cloths contaminated with dust or grit. Oxidisation will be quick to return, particularly if the metal is exposed to moist conditions; this, however, can be delayed by waxing or lacquering as for silver.

A note of warning before the cleaning of any metal is contemplated. As was mentioned at the beginning of this chapter, more irreparable damage, both to the aesthetic appeal of an object as well as to its value, can be done to metal objects in a few seconds, than to any other works of art. Before you clean any metal object, even if you suspect it as commonplace as an old silver serving spoon, have it looked at by an expert, establish what it is, its age,

value, whether it is permissible to clean it, and if so, if a professional's services are called for. There are certain items that should not be cleaned under any circumstances no matter how 'dirty' they look.

Oriental figures are a good example of a category of metal objects that should not be cleaned, for gentle polishing with a soft cloth will do wonders for their appearance, and their value will remain intact. This rule also applies to oriental vessels such as Tibetan teapots, horns and trumpets. Coins and archaeological objects too, particularly if recently found, should be taken to the local museum for an examination and opinion before any cleaning whatever is contemplated. This advice is in the collector's best interests, for if followed not only could a disastrous cleaning be avoided, but the expert will be able to make a more accurate analysis of an uncleaned object. The rule then is, if you don't know what an object is or if you are in any doubt about it, don't clean it.

As we have seen, copper and its alloys are very vulnerable to oxidation in damp conditions. When a bronze is buried in damp conditions the oxidisation builds up to form a layer of a mineral known as cuprite. On to this purplish-red layer other minerals can become incrusted giving a green or blue colour. This condition is in itself by no means harmful for if it is stable it often protects the underlying metal. However, if for any reason chloride from the immediate environment becomes trapped as the incrustation builds up, cuprous chloride is formed which has a corrosive action on the metal and is potentially unstable.

Known as 'bronze disease', the most recognisable symptoms of this corrosive action are pale green or blue powdery spots on the surface of an object. Caused by chloride and considerably aggravated by damp, such problems are not always confined to the surface, but can be hidden beneath compacted layers of cuprite. If left unchecked and in the presence of adverse conditions, the object would continue to corrode until, in time, very little of the metallic core would remain. To check the corrosion, then, the minutest traces of chloride must be removed from the surface

and with much greater difficulty from within the incrustation. As cuprous chloride is insoluble, washing with water is not the answer and careful consideration must be given to other methods.

As the results of the conservation of metals can be so unpredictable and variable, depending on the individual problems, it is important to practise and learn from the effects of the methods described below on worthless metal objects.

Whatever methods are employed, certain materials will be needed:

(1) A quantity of distilled water for making solutions and rinsing.

(2) Hypodermic needles (easily purchased from any pharmacy) for picking away incrustation if this is necessary.

(3) A *soft* shoe or nail-brush for brushing softened incrustation if necessary.

(4) One or two glass or polypropylene beakers with measuring divisions down the side (available from a pharmacy or photographic shop).

(5) A small quantity of dilute nitric acid (any concentration) and a small quantity of dilute silver nitrate (17 grams of silver nitrate dissolved in 1 litre of distilled water), both can be made up by a chemist.

A simple question must be asked before treatment can begin. Can the patina or incrustation be sacrificed, or must it be preserved? The safest answer to this question from the point of view of the inexperienced is that the patina should be retained and that a less drastic form of treatment should be employed.

Treatment when patina or incrustation must be preserved 'Bronze disease', the most common symptom of the presence of chloride and an indication that corrosion is taking place, usually takes the form of an outbreak of powdery spots which are usually pale green or blue/green. When they occur on objects with good surfaces and patinas they can take the form of (1) spots on thin, soft areas of patina that can in themselves be patchy and possibly

streaked with brown cuprite, and (2) spots that occur on thick, hard patina or incrustation.

(1) Where the symptoms are on thin incrustation or patina that is in itself patchy or hiding a detail or ornament that would be best exposed without a drastic overcleaned effect. Under these circumstances the bronze can be soaked in a 5% solution of sodium sesquicarbonate made with distilled water. See also 2a below.

 This process will probably take some weeks, so the solution will need changing at regular intervals. Each time this is changed the bronze can be gently rubbed or brushed, and also any loose material can be carefully 'picked' using a hypodermic needle, and the soaking continued until the desired effect is achieved. Unless your skin is sensitive, contact with this solution is harmless, but the hands should be rinsed after its use. When the treatment is complete, the object must be thoroughly washed in changes of distilled water to rinse away all traces of chloride. Ideally, the last rinse water should be tested with silver nitrate as follows: To be really sure that all the chloride has been washed away, 10 ml of final rinsing water in a tall glass vessel is tested by adding a few drops of any concentration of dilute nitric acid (a dangerous chemical), adding a stopper and shaking. To this a few drops of dilute silver nitrate is added. This is then stoppered and shaken. After allowing a little time for reaction to take place the solution is held up to a good light. If it becomes cloudy, chloride is still present and washing to eliminate chloride should proceed further. It should, however, be pointed out that this test is most effective under laboratory conditions, but it could still be a useful indication to the amateur.

 If the metal needs darkening, this can be achieved by boiling in distilled water for a few hours until the desired effect is achieved. The object should then be thoroughly dried by gentle exposure to warm air, but must be thorough,

remembering that the presence of moisture could be a contributory factor to another outbreak of 'disease'. The bronze can then be polished with a lightly waxed brush (see Formulae) to bring up the surface.

(2) Where there is a heavy uniform patina or incrustation that shows isolated spots (that may be increasing in size) or on an object where the patina is particularly fine or the object too large to expose to the rigors of the process mentioned above, the outbreak can be treated locally.

This is done by first brushing any powdery deposits from the individual spots and then applying to each spot a tiny amount of zinc powder. To this is added a drop of 90% sulphuric acid (a dangerous chemical) with a fine glass capillary tube. Rubber gloves should be worn and there should be a supply of running water for dousing the skin in case of emergency. Great care must be taken not to allow acid on to any other part of the bronze as if this happens the surface will be irreparably damaged. The spot will effervesce for some seconds and after this has taken place the area should be rinsed with a stream of distilled water, patted dry with cotton wool and inspected. If treatment has not been satisfactory it must be carefully repeated. The chloride should in fact have been rendered soluble by this local reduction and so should be able to be washed away, leaving a dull brown spot. If treatment seems satisfactory, the area must be thoroughly dried as above and can be locally waxed to bring up the surface.

As sulphuric acid is a dangerous chemical, its use must be given due consideration and care. Sulphuric acid can cause serious burns, so protective gloves must be worn and precautions taken. Should the skin be burned by sulphuric acid it should be flooded with water and then bathed with a solution of bicarbonate of soda. Most pharmacists will make up a small quantity of sulphuric acid for you. If you make the solution yourself, remember that concentrated acid should always be added to water carefully and *slowly*

with continuous stirring to counteract the large amount of heat evolved. *Always acid to water **never** water to acid.*

(2a) This same local treatment can be achieved without the use of acid, using the 5% sodium sesquicarbonate solution mentioned in (1) to make a paper pulp with shredded colourless blotting paper. Make up only enough solution to last a few days and apply the paper pulp to the affected areas only each day. Be patient, this process will take a long time, as its action is very gentle, but it should have the effect of stopping the corrosion, and for this reason it is a very useful and safe treatment that can be employed by the inexperienced. When completed, washing, drying and waxing can be carried out as above.

Calcareous deposits Even when bronzes are stable they are sometimes covered with a hard, whitish, chalk-like deposit. This is quite common on antiquities. In small quantities these deposits do not detract from the beauty of an object, but in other cases can mar its appearance altogether and the object would benefit from their removal. This is done by soaking the object in a 5% solution of sodium hexametaphosphate or Calgon as it is sometimes known. This process takes time, but has the effect of making the deposits soluble so that they can be brushed or picked away without endangering the patina. As mentioned above, the object must be carefully rinsed, dried and waxed, if necessary, once the treatment is completed. For further uses of Calgon see next section.

Treatment when the patina or incrustation can be sacrificed When a metal object is heavily corroded and unstable, but has some metal core remaining and a surface that can be sacrificed, the most efficient way of removing chloride and reducing the products of corrosion is electrolytic reduction or electrolysis. The equipment required can be quite costly and should never be used on an object of unknown provenance or of value. Experimentation must first be carried out on objects of no value until a technique for using

the equipment, which is very similar to that used for electroplating metals, is mastered.

Some form of tank will be needed, i.e. a container for the liquid electrolyte which can be a polythene ice-cream container or glass jar, depending on the size of the object to be treated. Into this two iron or iron gauge sheets are suspended from metal rods, laid from edge to edge of the container. Between these the metal object is hung by copper wire from another bar placed between the two mentioned earlier. See colour plate 12.

The two metal sheets are known as the anodes and the object as the cathode. The anodes are connected to each other by copper wire and are in their turn connected to a positive source of direct current. The cathode or object to be treated is connected to the negative source of direct current. The current can be from an accumulator or car battery or from a source connected to the mains. Such a unit is described on the following page.

With the current off or the apparatus disconnected a 2% solution of caustic soda is placed in the tank until it covers the object by about 5 cm, taking precautions that it does not touch the metal rods.

The current is then switched on. In order that current should flow easily between the anode and the cathode it is best to allow the object to soak in the electrolyte (the solution) overnight before staring the electrolysis. The optimum current density is about 1 amp for every 20 square inches or 10 amps per square decimetre of cathode area.

Care should be taken when treating copper and its alloys or silver to ensure that the output does not fall below 2 amps per square decimetre as a copper deposit could build up over the object. Generally speaking, however, the lower the current density, the more effective the result. As the corrosion is reduced the resistance is lowered and should be compensated for by altering the variable resistance in the circuit.

The object of electrolysis is to generate hydrogen at the cathode (the object), reducing the corrosion to finely divided copper. The reduction of a thin crust 3 mm thick will take about three to four

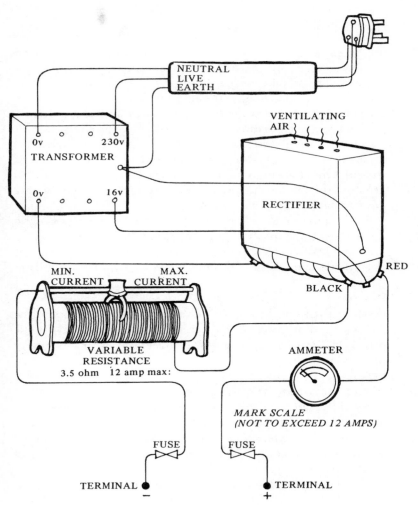

NEUTRAL
LIVE
EARTH

0v 230v

TRANSFORMER

0v 16v

VENTILATING
AIR

RECTIFIER

RED

BLACK

MIN.
CURRENT

MAX.
CURRENT

VARIABLE
RESISTANCE
3.5 ohm 12 amp max:

AMMETER

*MARK SCALE
(NOT TO EXCEED 12 AMPS)*

FUSE

FUSE

TERMINAL ●
−

● TERMINAL
+

Apparatus for electrolysis.

47

days. It will be necessary and advisable to change the electrolyte solution about twice during this time.

The process will be complete when all the chloride previously combined with the metal has combined with the hydrogen formed by electrolysis. This will be indicated by the free flow of gas at the cathode, even at low current densities.

After treatment the object should be thoroughly soaked, rinsed in changes of distilled water to eliminate all traces of the electrolyte, and brushed to remove any loose corrosive products. It must then be thoroughly dried either by exposing to gentle warm air or, if the object is small for example, passing through a bath of alcohol. Once thoroughly dried, the surface can be highly waxed or, more suitably in the case of iron and steel, lacquered with a product such as Ercalene.

A solution of up to 15% sodium hexametaphosphate or Calgon can be used to remove the green incrustation completely, given time and several changes of solution. Calgon is also useful for cleaning up the surface of bronzes where no metal core remains.

Pewter

Pewter, usually an alloy of tin and lead or more often in modern pieces tin and antimony or copper, develops a particularly subtle patina. It is important, then, not to overclean it, or the surface subtlety which is its charm will be lost. Ordinary oxidation can usually be overcome by one of the commercial non-abrasive cleaners provided they are recommended for pewter. Sometimes old pewter is marred by a thin layer of corrosion in the form of hard lead carbonate, which will not respond to ordinary cleaning. Pewter should not be stored in oak drawers or cupboards as the tannic acid these give off can have a corrosive effect on lead or its alloys.

This can easily be removed by placing the pewter object on a bed of an ion exchange resin in a suitable container, and then covering the object completely with more granules. This is then covered with distilled water and kept hot, changing the resin as necessary until the white deposit has disappeared. When

treatment has been completed the pewter must be thoroughly dried (rinsing is not necessary as no chemicals have been involved) and lightly waxed if required.

Any spot-like incrustations that may appear on the surface of old pewter, due to the localised presence of salts, are probably best left alone unless the corrosion is obviously active and threatening the object. If this is the case, expert advice should be sought as treatment to correct the corrosion will no doubt have a marked effect on the appearance of the object.

Iron and Steel

In the case of objects made from iron and steel, the greatest enemy is damp. When the relative humidity is high, moisture can so easily condense on to cold surfaces of objects such as arms and armour. Added to this, the sulphur dioxide in our city atmospheres could be present in the moisture that condenses on to the cold metal surface, all helping the production of rust.

Rust is the name we give to the orangey-red deposit that is the symptom of corrosion on iron and steel, and is a complex and fascinating mixture of chemical and electro-chemical reactions. As in the case of copper and its alloys, the corrosion of iron is prompted by the presence of moisture and salts and similarly, in the case of corroded unstable iron objects, these salts must be eliminated if the object is to become stable.

The presence of even the tiniest amount of rust is disturbing, particularly in damp conditions, and all too often can quickly result in unsightly pitting into the surface of the metal. It is therefore very important to take precautions to protect objects, particularly those in good condition, and so prevent rusting. This can be done by regular and careful inspection, by careful storage in dry conditions and by the use of protective wax and lacquer on the surface of the metal.

Objects that are not on permanent display can best be stored, when free from any moisture, wrapped in 'aired' tissue paper and sealed inside polythene bags. The metal surface can also be protected by light waxing with microcrystalline wax (see Formulae),

applied extremely sparingly with a silver brush, and then polished with another soft brush to remove all but the minutest coat. If an object is overwaxed, the dust and dirt that the wax attracts could easily cause scratching, particularly in the case of swords drawn in and out of scabbards. Alternatively, the object can be lightly lacquered with such products as Ercalene, after degreasing with methylated spirit, although the result is a fairly glossy surface.

Where rust spots occur, action must be taken quickly to remove them before the surface of the metal becomes pitted. Rust can be removed locally, but only after it has been softened. This can be achieved by soaking the object in paraffin (kerosine) and then very carefully rubbing the rust patches with small pieces of, preferably worn, wet or dry paper. Great care must be taken not to overclean the spot or any of the surrounding areas, which would result in unsightly areas of overcleaned metal. After gently rubbing away the rust, all the paraffin must be completely cleaned away and replaced by lubricating oil while continuing to bring up the surface with a clean, soft cloth. Any residue of oil is then wiped away, leaving the object as dry as possible.

Commercial rust softening and removing products can also be used instead of the paraffin, and are particularly useful for objects that are too large to be soaked in paraffin (kerosine). Plus Gas Fluid A is a very efficient rust softener and can be used with products such as Jenolite, which is a rust remover. It is wise to test all the above methods on objects of no value first, particularly to judge their abrasiveness so that a patchy overcleaned effect can be avoided on a treasured object.

Reviving dulled damascene The intricate pattern in other metals often found on sword blades and known as damascene work, can often become dulled, and the beauty of the pattern marred. A dilute acid solution will revive this, but great care must be taken as the acid can itself have a damaging etching action on the metal if allowed to remain longer than absolutely necessary. Having degreased the blade with methylated spirit, 1·5 ml of concentrated

nitric acid (a dangerous chemical) is dissolved in 100 ml of industrial methylated spirit. Wearing rubber gloves to protect the hands, this solution is applied sparingly to the blade on swabs of cotton wool, beside a source of running water. The acid should be quickly rinsed away with plenty of water when it has done its job, which should be almost immediately after application.

It is better to re-apply the solution than to leave the first application in contact with the metal for too long. When the pattern has been restored, hopefully without damage to the metal, the object is thoroughly rinsed under running water and carefully dried. Later, when absolutely free from any moisture, the blade can be lightly waxed or lacquered. Concentrated nitric acid is a dangerous chemical which is highly corrosive and should not be allowed to come into contact with the skin. If this happens the skin will yellow and should be flooded with water and bathed with a solution of bicarbonate of soda.

An iron object whose surface is completely covered with a thick layer of incrustation may not necessarily be unstable. If it is stable it must be carefully stored (as above) and inspected regularly to ensure that it remains so. A good indication that corrosion is still taking place, due to the presence of chloride, is when tiny yellow beads of moisture collect on the surface.

If the piece is unstable, expert advice must be sought to establish the age and value of the object. Electrolysis is probably the most effective way of eliminating the chloride, and therefore arresting the corrosion, although this is a particularly difficult process in the case of iron and would only be practical provided enough metal core remains. Hence an opinion on the object is essential.

5 *Ivory and Bone*

Ivory is the term used to describe the tusks of the Indian or African elephant, or walrus tusks or teeth. Bone has the same composition, but the structure is slightly different being coarse and more open, whereas ivory is denser and harder. This difference is easy to see under the microscope, but it takes some experience to distinguish between bone and ivory with the naked eye. However, from the point of view of care and repair they can be treated as the same substance.

Hopefully the appalling exploitation of the elephant for ivory will soon be stamped out for the sake of a majestic animal. It is doubly sad that many of the works of art produced in ivory, whether they are objects of merit or rather crude trinkets for the tourist, have much less chance of survival than their counterpart produced in previous days that we now call antiques. Newly carved works of art brought so carefully from East to West all too often just cannot cope with the change in environment and the rigors of our centrally heated homes.

Ivory and bone, somewhat like wood, respond physically to changes in temperature and relative humidity. In particular it is hygroscopic, i.e. it takes in and gives off moisture, swelling and shrinking as it does so, resulting all too often in uneven and disfiguring warping and cracking. The thinner the ivory the more vulnerable it is and when held can even be seen to warp due to the warmth and moisture of the hands. For this reason a moderate and constant temperature and relative humidity should be strived for wherever possible. The ideal would be a relative humidity

of 55% and a temperature of 18 °C (65 °F) (see Introduction). Extremes in temperature should always be avoided, such as positioning ivories near fires or radiators or conversely exposing them to draughts from doors or windows or the dampness of outside walls. Sunlight can also be extremely harmful for this may cause patchy bleaching, with the heat causing drying and warping.

Provided the surface of an ivory is sound and clean its appearance can be enhanced by applying a tiny amount of almond oil to the surface from time to time with a cotton-wool swab. If two much oil is used, however, the ivory will attract dust and dirt and the opposite will be the case.

When storing ivory the most suitable packing material is completely dry acid-free tissue paper. With the ivory packed in such a way to allow some air movement to discourage the growth of moulds and bearing in mind what has been said above, no coloured material of any kind should be used and care should be taken that the ivory does not come into contact with any metal or rubber objects.

Cleaning
Careful and regular dusting with a soft, clean cloth can prevent the build up of grime and make any further cleaning unnecessary. If, however, dust or grime still persists, it can be removed with a solution of acetone and ammonia in the proportion of a cupful of acetone to a teaspoon of ammonia. Carefully stored in a well-stoppered bottle this should be applied with frequently changed cotton-wool swabs, wrapped around a wooden stick, that are only just damp, excess solution should be avoided and care taken not to rub the grime into the porous surface of the ivory. The solution should not come into contact with the skin, and care must be taken when handling ammonia and its storage afterwards.

Ivory can be cleaned in exactly the same way using a cupful of water with a few drops of good-quality liquid detergent, but this method which introduces moisture to the ivory is not without its dangers and can cause warping and splitting. If it must be used

53

in preference to the acetone/ammonia solution it is vital that the cotton-wool swabs are only damp and that the dirt is not rubbed into the surface. The ivory must be carefully dried after cleaning. The same principle applies to ivory- or bone-handled cutlery, which should never be plunged into a bowl of hot washing-up water, hastily dried and returned to a drawer until the next special occasion. If this is done disaster will surely follow. Never immerse the handle, but if accidentally swamped, be sure to dry thoroughly.

Bleaching

Ivory that has yellowed due to the formation of a natural patina over the years can be bleached if necessary, but this should not be undertaken on works of art as their charm and value can be obliterated at a stroke. More often than not, even in the case of domestic articles such as cutlery, a mellowed appearance is preferable to a stark, bleached one. Where bleaching is required, it can be achieved by mixing whiting to a smooth paste with '20 volumes' hydrogen peroxide, wearing rubber gloves to protect the skin and taking precautions against spillages. The surface of the ivory is then coatedwith the mixture, taking care not to overlap on to any metal. After a very short time this is removed and the surface wiped over with moist swabs to remove all traces of the mixture, carefully dried and examined. If necessary the process can be repeated until the desired effect is achieved, but avoid overbleaching.

Repairing Ivory

Any repairs to ivory can be undertaken using a polyvinyl acetate emulsion that is easily available in small quantities marketed as a wood-working adhesive under the name of 'Evo-Stick Resin W'. It is water soluble and any excess can be removed with a damp (and only damp) swab during bonding or with acetone once set. Resins and 'wonder' adhesives that 'bond in seconds' should not be used as they are not only difficult to remove if necessary but,

being stronger than the structure of the ivory, will not give as the ivory responds minutely to changes in relative humidity and temperature causing strain and possibly resulting in warping and cracking.

6 *Furniture*

It is completely beyond the scope of this book to mention anything more than basic first aid and preventive measures for furniture. A knowledge of the ways in which wood behaves and the techniques and skills needed to make it into furniture, and therefore restore it, are something that develops with time and experience. The restoration of valuable furniture is something that unquestionably should be placed in the hands of an experienced restorer and the collector should not be afraid to approach the most reputable dealers of finest quality antique furniture for quotations and advice on whom to contact. It goes without saying, therefore, that it is vital to identify and value antique furniture, so that any work, whether undertaken by the collector or a professional restorer, can be put into perspective.

What is not beyond the scope of this book is advice on how to care for antique and modern furniture so that hopefully the restorer's skills will not be needed. The following will apply to both modern and antique furniture, for wood responds to its environment whether hundreds of years old or modern. As is explained in the Introduction, wood is susceptible to changes in relative humidity and extremes of temperature, a problem that is exaggerated when varying woods, adhesives and joints are incorporated in the making of a single piece of furniture.

The most dangerous times for furniture in the house are when the heating is being turned on and off in either the autumn or spring, at night if the temperature is allowed to drop dramatically, and during times of very cold dry weather when the relative

humidity is probably very low. Wood being a hygroscopic material, its moisture content depends on the relative humidity of its environment and when this changes dramatically so does the structure, and warping and cracking can result.

Insect pests are also a great enemy of furniture and woodwork and once their presence is discovered the object must, wherever possible, be isolated and treated as soon as possible. They are mostly of four types:

(i) the commonest of all is the Furniture Beetle (*Anobium punctatum*), which prefers older wood rather than newly seasoned;

(ii) the House Longhorn Beetle (*Hylotrupes bajulus*), which does not attack hardwoods but prefers soft newly seasoned wood;

(iii) the Powder Post Beetle (*Lyctus brunneus*), which likes sapwood and newly seasoned or unseasoned wood;

(iv) the Death Watch Beetle (*Xestobium rufovillosum*), prefers hardwood and older structural timbers.

In the case of all these wood-boring insects it is not the beetles that cause the damage but the larvae or grubs. We can generalise on their life cycles as follows. Eggs are laid by the female beetle in crevices, rough surfaces, old joints and even old worm holes. Within about four weeks they hatch and the larvae or grubs tunnel into the wood to find protection and nourishment. This tunnelling carries on for a minimum of one year and a maximum of five. When fully grown the larvae change into pupae or chrysalises which then, during metamorphosis which takes a few weeks, change into the adult beetles. The emerging beetles then bite their way out of the wood, which is usually around May to August, creating the characteristic worm holes and escape to mate and soon after die.

The presence of worm holes does not automatically mean that deterioration is taking place, only that beetles once emerged from the wood. What is more significant is if the edges of the holes, are sharp and clean and the wood inside fresh looking, or if traces

of wood dust are around the hole or on the floor, or perhaps a faint munching noise is heard, particularly noticeable in the dead of night!

As we have seen, it is the larvae that are causing deterioration and if this is to be checked the larvae must be poisoned. This can be achieved either by a toxic gas or fluid, which must come into actual contact with the woodworm, protected as it is deep inside the body of the wood. For this reason fumigation by toxic gas is the most efficient method as the gas has a greater chance of permeating all the tunnels, although its effects are only immediate and will stop further deterioration but will not afford long-term protection.

Many substances are used for fumigation of furniture and wooden sculpture, some of them highly lethal to man. The heavy vapour of carbon disulphide, however, can be used with safety by the collector, provided he is careful to take precautions and use commonsense.

As can be seen in the colour illustrations, the object to be fumigated is enclosed in a container, which can be a biscuit tin or a heavy-duty polythene tent with any opening meticulously sealed with freezer tape, and then the cubic footage of the container calculated. The method described below is not suitable for paintings on wood, or furniture with delicately coloured upholstery. Carbon disulphide vapour is *inflammable, highly explosive* when mixed with air and dangerous if inhaled, and so great care must be taken that no naked lights are around, and that there is good ventilation. See appendices on dangerous chemicals.

The fire risk can be reduced by mixing four parts of carbon tetrachloride to one part of carbon disulphide. For every cubic foot of container, i.e. polythene tent or tin, 57 ml of liquid will be required. This is poured into a dish which is placed above the object to be fumigated (see colour plate 15), as the vapour given off is heavier than air. The container is then quickly and carefully sealed. This is then left for twenty-four hours in a minimum temperature of 15·6 °C (60 °F) in a safe place away from tampering fingers! After this time the liquid can be replenished, the container

quickly resealed and left for a further few days to ensure complete penetration.

The other method of killing woodworm is by applying poisonous fluid. This is readily available in small quantities under branded names. It must be remembered that deterioration will not be checked unless this fluid actually comes into contact with the woodworm and so treatment must be systematically carried out and no hole missed. Although most products come in containers with special nozzles, a hypodermic syringe is most effective in getting deep down into the wood. Provided the poison reaches the woodworm, deterioration will be checked with the added advantage that it will remain for some time in the body of the wood to counteract further infestations. Commercial fluids can also be painted on to the surface of wood to act as a deterrent provided the wood is not highly polished. Late spring and summer are the best times for such treatment and should be carried out for at least two consecutive years. It goes without saying, however, that treatment should always be carried out immediately deterioration is suspected and manufacturer's instructions carefully followed.

Repairing of Joints and Broken Members
One of the most frequent problems that the collector of furniture meets is that of broken or frail chairs. This is due to the fact that the chair is made up of a number of sections, each one glued to the other. With age this glue, which is usually animal based, deteriorates, resulting in the sections parting and the joints becoming weak. In some cases the sections were joined together with the aid of dowels and where this is the case the joints can be brought together relatively easily. It is important that loose joints are repaired as soon as possible for if not, the whole balance of the piece could be spoiled.

Polyvinyl acetate emulsion or a similar proprietary woodworking adhesive, such as Evo-Stick Resin W, is an ideal adhesive. This is applied to one surface after the joint has been thoroughly cleaned of any old adhesive, and lightly sanded, or after the manufacturer's instructions have been followed. The two surfaces to

be joined can usually be held together, while the adhesive is curing, by a tourniquet system using bandages and a wooden batten, such as indicated in the colour illustrations. The tourniquet can be applied in several ways, which is indicated by the shape of the piece of furniture. It is important to protect the surface of the wood from pressure or damage while this is being done.

Loose joints can be strengthened without dismantling by cleaning the joints, then scraping adhesive between them and carefully bringing the assembly together, securing with a tourniquet. Take care not to put unbearable strain on the rest of the object. For the inexperienced this has the advantage of strengthening the piece (although it is by no means infallible), without the complication of taking it to pieces, which is the ideal.

Horizontal movement in the frames of either chairs or tables can be rectified by fixing wedges out of sight at the corners of the frame by adhesive and screws. Never use screws on furniture unless the object is of little value. Vertical movement can be corrected in a similar way, although in most cases this will be visible and will need to be carefully shaped to fit and match the piece of furniture.

Broken members may need strengthening by the insertion of wooden dowels. These are available commercially as pins or rods which can be cut to size. Breaks of this kind are normally found on table and chair legs and curved pieces of wood under stress. Always ensure that the dowel fits tightly, so the hole drilled should always be marginally smaller than the dowel. Adhesive is then applied to the edge without the dowel and the two pieces brought together, and tied until the adhesive is cured. Any excess adhesive must be wiped away with a damp cloth as the joints are brought together. A point to be remembered is that the dowel must always be inserted at right-angles to the break.

Cleaning and Polishing Furniture

Cleaning grime and accumulated dust from furniture can be achieved by the cautious use of a mixture of one part linseed oil, one part white vinegar, one part turpentine and a quarter part

of methylated spirit, vigorously shaken together before use. Care should be taken not to rub the grime back into the wood.

For day-to-day care of fine furniture the best polish to use is a microcrystalline polish which can be simply made up (see Formulae) and if stored in air-tight jars will last a long time, as it is only used sparingly and is quite economical. Microcrystalline polish, *if used sparingly*, has the advantage of not only giving a fine finish, but also cleaning and protecting wood, leather and any metal additions. Once rubbed in with a soft cloth it is left for a while before buffing.

When metal additions such as handles are present care must be taken that these are not cleaned with coarse metal polishes or solvents that are allowed to spoil the surface of the wood. This can easily be overcome by carefully applying metal polish (see chapter on metal) on tiny swabs of cotton wool on the end of a stick and by cutting a template of cardboard, paper or polythene so that any polish discolours the template and not the wood.

Removal of Stains and Dents
As a general rule, stains and dents in antique or valuable furniture are best left alone. Not only do they tell a story about the piece of furniture and contribute to its 'old' appearance, they have probably changed in composition over the years making their removal almost impossible and detrimental to the wood.

Modern or older furniture of no value is, however, different, particularly if the mark is detracting from the beauty of the piece. Careful thought should be given to the problem before attempting to remove a stain and the work should proceed with caution.

Ink stains With an artists' brush carefully apply a little vinegar to the stain (not the surrounding wood). Repeat the process using a 10% (100 ml to 1 litre) sodium hypochlorite solution (Milton) with a swab of cotton wool at hand to remove any excess. The stain will gradually bleach, so be prepared to stop this action with a wet swab before it goes too far. It is better to have to repeat the process several times than spoil the wood. The stain will probably

not be removed completely, but when a satisfactory result is achieved, the surface is rinsed with a swab of cotton wool. When thoroughly dry it can be built up with microcrystalline polish to which a little coloured pigment has been added, if necessary.

Water marks White water marks can probably be removed, but if the moisture which causes them has penetrated deep into the wood, they are best left alone, as their removal will probably result in an even more jarring effect. The white mark, caused by condensed moisture slowly evaporating, might respond simply to gentle rubbing (with the finger) around the stain with linseed oil. The warmth generated by this action, combined with the oil, might prove effective. Remove any excess before repolishing. Alternatively, a mixture of four parts of linseed oil, that has been carefully simmered for fifteen minutes (taking necessary precautions against fire), is added, when cold, to one part of turpentine and the mixture shaken and applied liberally to the area. This can be left for a time if necessary, but any excess must be removed before the surface is repolished.

Bloom White bloom, which is generally caused by polishing a surface while moisture is present, can be rectified by carefully removing the last layer of polish with white spirit, and taking with it the bloom. The surface is then left to dry thoroughly. It can then be repolished.

Dents Dents can be removed, but the process requires care. A thick, damp (not too wet) cloth is placed on the surface, covering the dent and also protecting the rest of the wood. Gently, using the point only of an ordinary iron on the coolest setting, a little heat is placed carefully and specifically on the dent. This should result is gentle warmth and evaporating moisture from the cloth penetrating the area of the dent (and the dent only), resulting in a slight swelling of the area and the dent being improved. The process might need repeating with a freshly dam-

pened cloth, but have patience and do not let the surface get hot. Take care to let the surface dry thoroughly before polishing.

Gesso and Lacquer Furniture
Some furniture is decorated by covering the wood with layers of gesso and carving decorations in relief, which are then gilded. Picture frames, in particular, were often made in this way, but all gesso objects are very vulnerable and the smallest knock can cause damage. Their repair is quite a skilful job and necessitates a degree of artistic skill in keeping the quality of the piece.

Gesso is made by mixing whiting with dilute size in a double boiler until the correct consistency is achieved. Alternatively, cellulose filler can be used most successfully particularly for small jobs, or for the inexperienced, as it is much easier to use than gesso.

The area to be replaced should first be carefully brushed clean and, if it is large, a few panel pins can be inserted for support. The gesso should be inserted into the dampened area and modelled into the shape required. It is then left for about an hour to harden, after which time the details can be carved away with a scalpel. Small cracks can be filled in by rubbing gesso over the area with the finger and wiping away any excess with a damp cloth.

In the case of cellulose filler, the surface is first moistened and then painted with filler watered down to the consistency of water-colour paint. The putty is then pressed into position and modelled roughly with a fine palette knife. The modelling is then finished off with a wet brush, which is so simple that it is great fun, provided the surface is not flooded with water. When any relief is satis-factory this is left to dry thoroughly.

Both real and artificial gesso should be smoothed down completely as any imperfections will be very apparent once paint or gold is applied. This is done initially with fine abrasive paper and finished with very fine abrasive paper such as Flexigrit. Time spent on smoothing down will be well rewarded in the finished result.

Before finishing, the dust-free repair has to be sealed with an

isolator such as methylated spirit and shellac, or size. This will seal it and when thoroughly dry allow it to be painted and gilded. The use of an isolator is not always necessary when using a cellulose filler. This being done the repair must be given a ground by painting with burnt umber artists' oil paint diluted with white spirit. The surface can then be gilded by applying gold leaf (see chapter on porcelain) or a good-quality liquid gold, chosen to match the original. Commercial 'metallic' gold paint should be avoided. It is most unlikely that the gilding will match exactly, but where necessary it can be toned down by brushing over a very dilute coat of raw or burnt umber. When finished and thoroughly hard, the repair can be polished with wax.

This method applies to all gesso-covered furniture, but should not be carried out on valuable pieces. Such pieces should be put in the hands of an experienced furniture restorer.

Chinese and European lacquer furniture can be repaired by using a modification of the technique described above. Serious cracks and loose surface (not on valuable pieces) can be replaced with gesso or filler as described above, but as most lacquer is flat care must be taken to ensure that any repair is flat and smooth and level with surrounding areas.

After sealing, a grey ground should be applied. The repair can then be painted to match the lacquer using techniques similar to those mentioned in the chapter on pottery and porcelain. A matt, semi-matt or glossy finish may be obtained using the technique described on page 27. Reference should be made here to the Introduction, as there may be an environmental fault causing cracks and damage to appear, and merely repairing a piece without adjusting the environment will result in only short-lived improvements.

Opposite: *Some of the tools used in repairing and restoring antiques.*

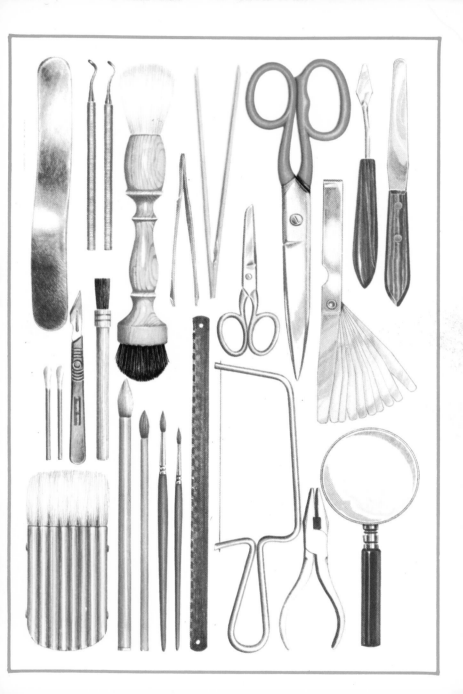

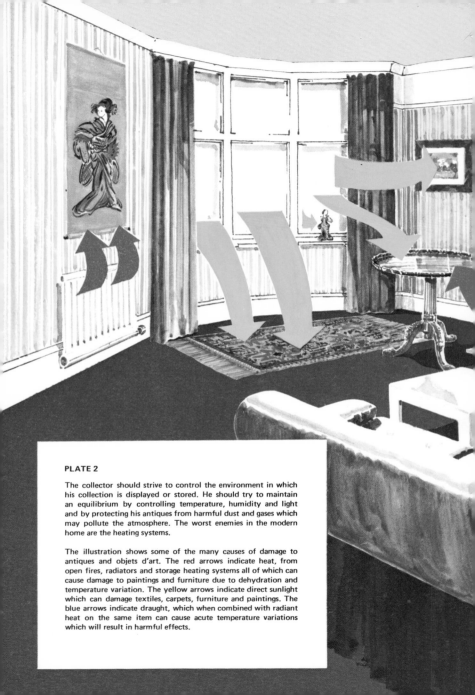

PLATE 2

The collector should strive to control the environment in which his collection is displayed or stored. He should try to maintain an equilibrium by controlling temperature, humidity and light and by protecting his antiques from harmful dust and gases which may pollute the atmosphere. The worst enemies in the modern home are the heating systems.

The illustration shows some of the many causes of damage to antiques and objets d'art. The red arrows indicate heat, from open fires, radiators and storage heating systems all of which can cause damage to paintings and furniture due to dehydration and temperature variation. The yellow arrows indicate direct sunlight which can damage textiles, carpets, furniture and paintings. The blue arrows indicate draught, which when combined with radiant heat on the same item can cause acute temperature variations which will result in harmful effects.

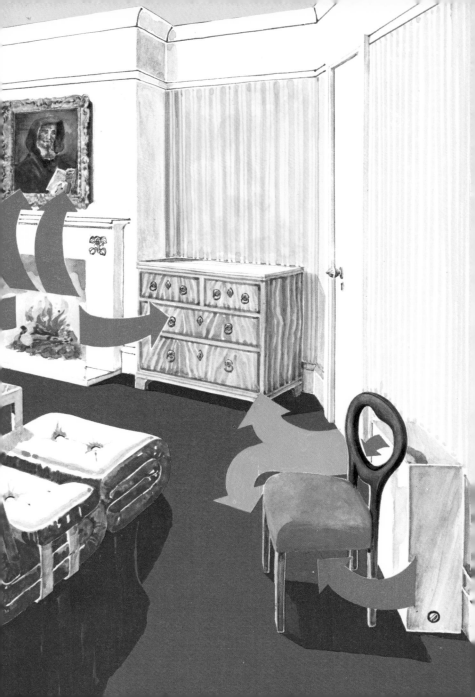

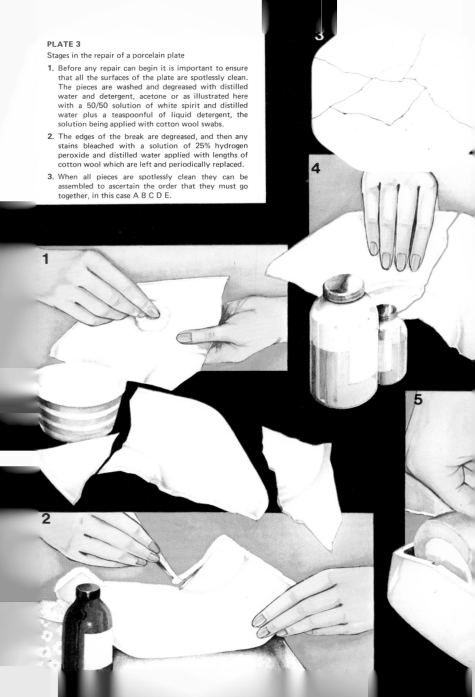

PLATE 3
Stages in the repair of a porcelain plate

1. Before any repair can begin it is important to ensure that all the surfaces of the plate are spotlessly clean. The pieces are washed and degreased with distilled water and detergent, acetone or as illustrated here with a 50/50 solution of white spirit and distilled water plus a teaspoonful of liquid detergent, the solution being applied with cotton wool swabs.

2. The edges of the break are degreased, and then any stains bleached with a solution of 25% hydrogen peroxide and distilled water applied with lengths of cotton wool which are left and periodically replaced.

3. When all pieces are spotlessly clean they can be assembled to ascertain the order that they must go together, in this case A B C D E.

4. An epoxy resin adhesive AY103 mixed with suitable colourant is applied and the pieces brought together.

5. The pieces are held together with transparent sticky tape while the adhesive is curing.

6. After joining, the cracks are filled with the same epoxy resin used for bonding, again suitably tinted.

7. Both surfaces are then carefully retouched to hide the join.

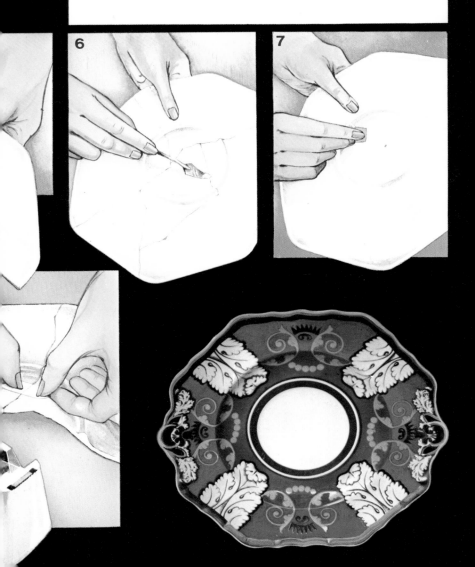

1

2

3

4

5

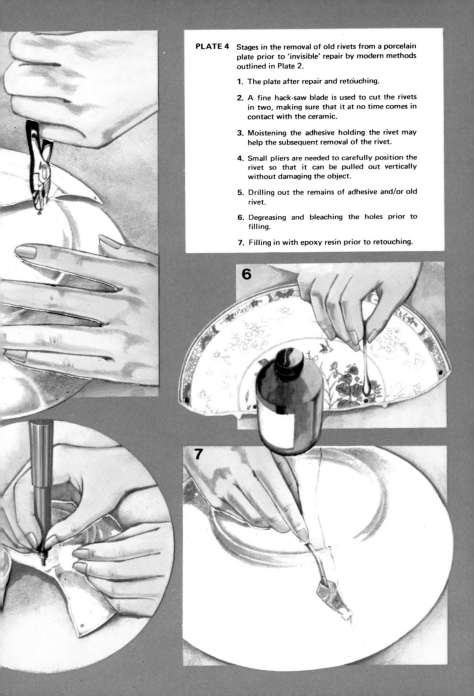

PLATE 4 Stages in the removal of old rivets from a porcelain plate prior to 'invisible' repair by modern methods outlined in Plate 2.

1. The plate after repair and retouching.

2. A fine hack-saw blade is used to cut the rivets in two, making sure that it at no time comes in contact with the ceramic.

3. Moistening the adhesive holding the rivet may help the subsequent removal of the rivet.

4. Small pliers are needed to carefully position the rivet so that it can be pulled out vertically without damaging the object.

5. Drilling out the remains of adhesive and/or old rivet.

6. Degreasing and bleaching the holes prior to filling.

7. Filling in with epoxy resin prior to retouching.

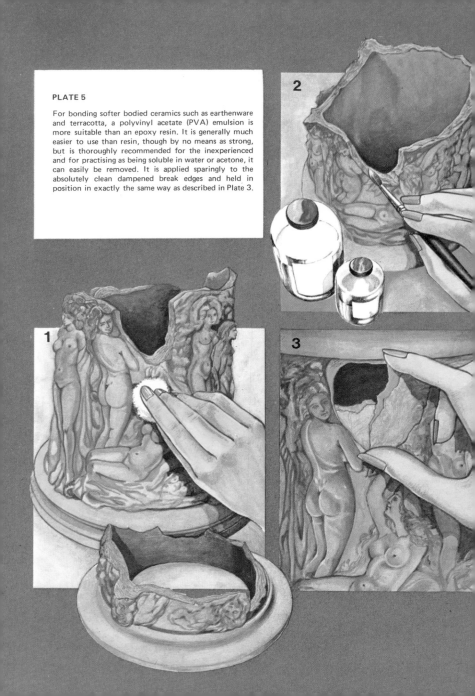

PLATE 5

For bonding softer bodied ceramics such as earthenware and terracotta, a polyvinyl acetate (PVA) emulsion is more suitable than an epoxy resin. It is generally much easier to use than resin, though by no means as strong, but is thoroughly recommended for the inexperienced and for practising as being soluble in water or acetone, it can easily be removed. It is applied sparingly to the absolutely clean dampened break edges and held in position in exactly the same way as described in Plate 3.

1

2

3

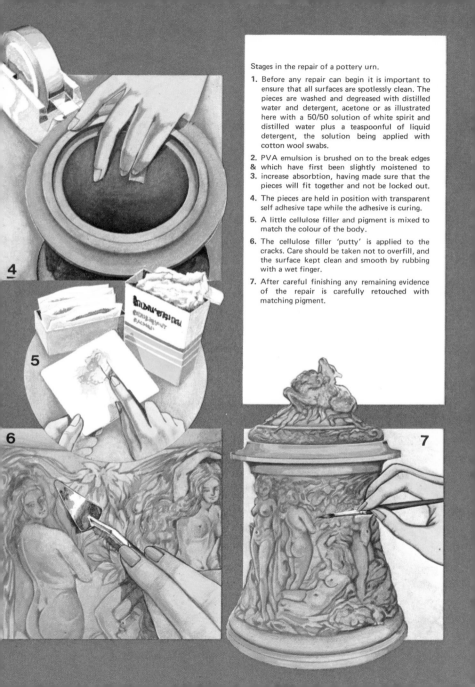

Stages in the repair of a pottery urn.

1. Before any repair can begin it is important to ensure that all surfaces are spotlessly clean. The pieces are washed and degreased with distilled water and detergent, acetone or as illustrated here with a 50/50 solution of white spirit and distilled water plus a teaspoonful of liquid detergent, the solution being applied with cotton wool swabs.

2. PVA emulsion is brushed on to the break edges
& which have first been slightly moistened to
3. increase absorbtion, having made sure that the pieces will fit together and not be locked out.

4. The pieces are held in position with transparent self adhesive tape while the adhesive is curing.

5. A little cellulose filler and pigment is mixed to match the colour of the body.

6. The cellulose filler 'putty' is applied to the cracks. Care should be taken not to overfill, and the surface kept clean and smooth by rubbing with a wet finger.

7. After careful finishing any remaining evidence of the repair is carefully retouched with matching pigment.

4

3

PLATE 6

Replacement of missing pieces. Here figures in a Chinese stoneware grotto which have missing heads are replaced by moulding from the surviving head.

1. The surviving head is isolated by a Plasticine well.

2. Re-usable rubber moulding compound is heated and poured into the well.

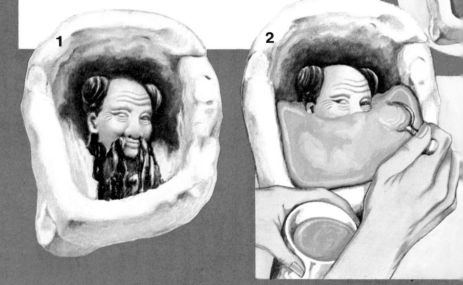

1

2

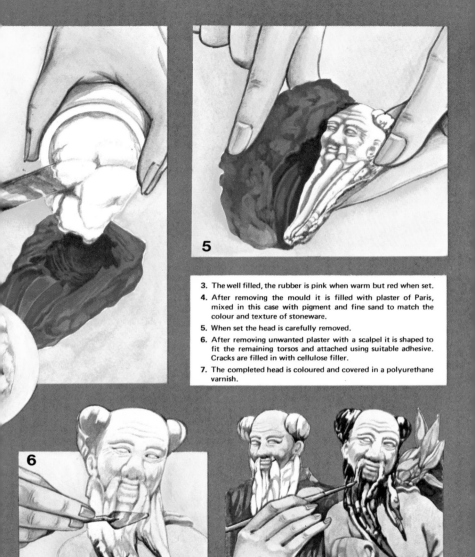

3. The well filled, the rubber is pink when warm but red when set.

4. After removing the mould it is filled with plaster of Paris, mixed in this case with pigment and fine sand to match the colour and texture of stoneware.

5. When set the head is carefully removed.

6. After removing unwanted plaster with a scalpel it is shaped to fit the remaining torsos and attached using suitable adhesive. Cracks are filled in with cellulose filler.

7. The completed head is coloured and covered in a polyurethane varnish.

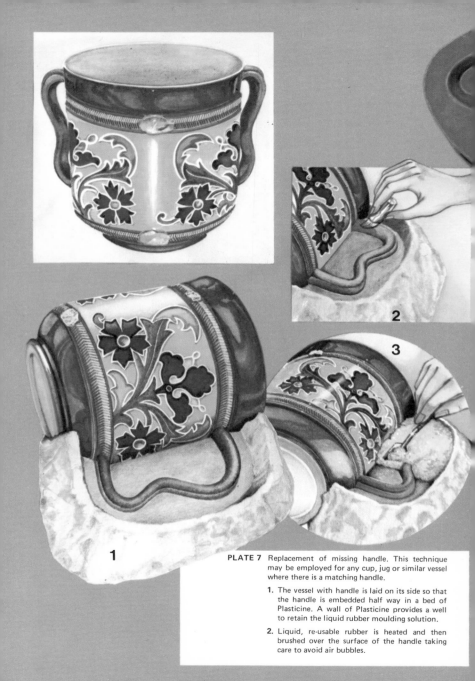

PLATE 7 Replacement of missing handle. This technique may be employed for any cup, jug or similar vessel where there is a matching handle.

1. The vessel with handle is laid on its side so that the handle is embedded half way in a bed of Plasticine. A wall of Plasticine provides a well to retain the liquid rubber moulding solution.

2. Liquid, re-usable rubber is heated and then brushed over the surface of the handle taking care to avoid air bubbles.

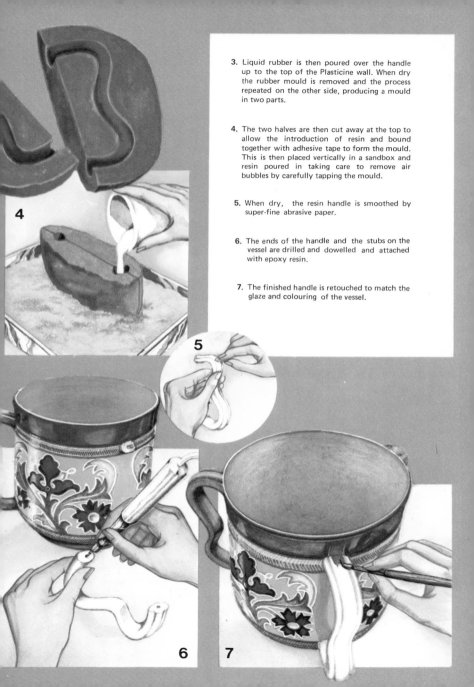

3. Liquid rubber is then poured over the handle up to the top of the Plasticine wall. When dry the rubber mould is removed and the process repeated on the other side, producing a mould in two parts.

4. The two halves are then cut away at the top to allow the introduction of resin and bound together with adhesive tape to form the mould. This is then placed vertically in a sandbox and resin poured in taking care to remove air bubbles by carefully tapping the mould.

5. When dry, the resin handle is smoothed by super-fine abrasive paper.

6. The ends of the handle and the stubs on the vessel are drilled and dowelled and attached with epoxy resin.

7. The finished handle is retouched to match the glaze and colouring of the vessel.

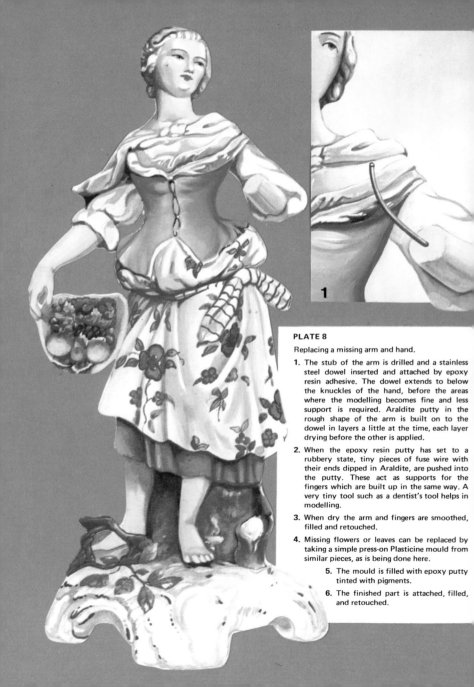

PLATE 8

Replacing a missing arm and hand.

1. The stub of the arm is drilled and a stainless steel dowel inserted and attached by epoxy resin adhesive. The dowel extends to below the knuckles of the hand, before the areas where the modelling becomes fine and less support is required. Araldite putty in the rough shape of the arm is built on to the dowel in layers a little at the time, each layer drying before the other is applied.

2. When the epoxy resin putty has set to a rubbery state, tiny pieces of fuse wire with their ends dipped in Araldite, are pushed into the putty. These act as supports for the fingers which are built up in the same way. A very tiny tool such as a dentist's tool helps in modelling.

3. When dry the arm and fingers are smoothed, filled and retouched.

4. Missing flowers or leaves can be replaced by taking a simple press-on Plasticine mould from similar pieces, as is being done here.

5. The mould is filled with epoxy putty tinted with pigments.

6. The finished part is attached, filled, and retouched.

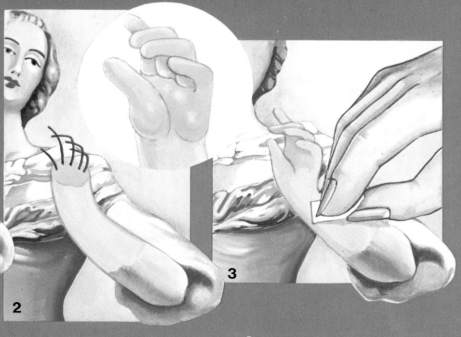

2

3

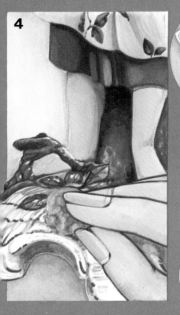

4

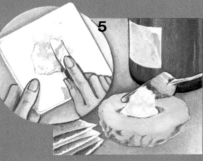

5

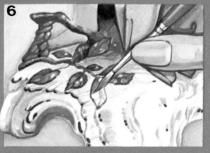

6

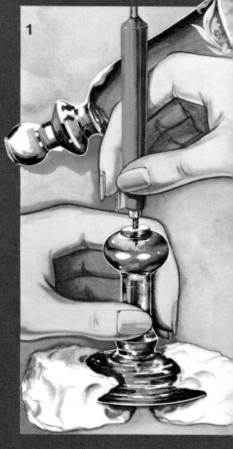

PLATE 9

One of the most common disasters to befall stemmed glasses is that the stem tends to snap.

1. The two halves are first washed and degreased (as for porcelain). A dab of paint is applied to one half, then the other, then brought together to mark the position of the dowel. Drilling is carried out with a diamond bit; both glass and bit must be kept cool by dousing with water.

2. After degreasing again, epoxy resin is applied to the dowel and one surface of the break. The dowel is then inserted.

3. The two halves are then carefully brought together.

4. After joining, the two halves are kept in position by adhesive tape from base to bowl. Excess adhesive must be removed before it sets.

Joining without a dowel is more risky. A cradle of Plasticine must be made to hold the two halves, which after the adhesive has been applied is held together by adhesive tape.

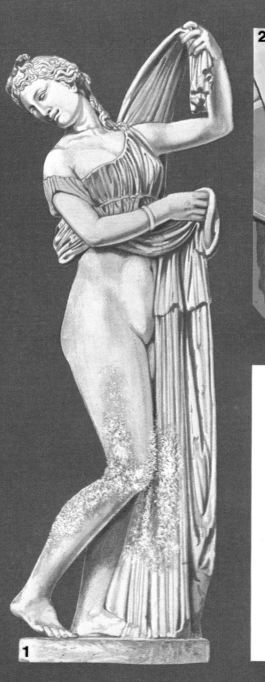

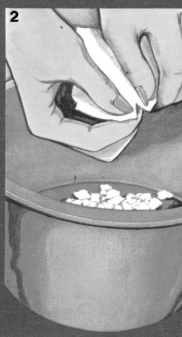

PLATE 10

1. Sculpture showing symptoms of "salting" with the appearance of salt crystals on the surface. If this is left unchecked, the surface of the sculpture will eventually break down. Pottery may also suffer from salting and may be treated in the same way.

2. Making a papier mache paper pulp. Here colourless blotting paper is torn up into little pieces.

3. The blotting paper is mixed with distilled water and mashed into a pulp.

4. The paper pulp is applied to the figure and allowed to dry, drawing out soluble salts as it does so.

5. After replacing the paper pulp several times, the sculpture is given a protective coating.

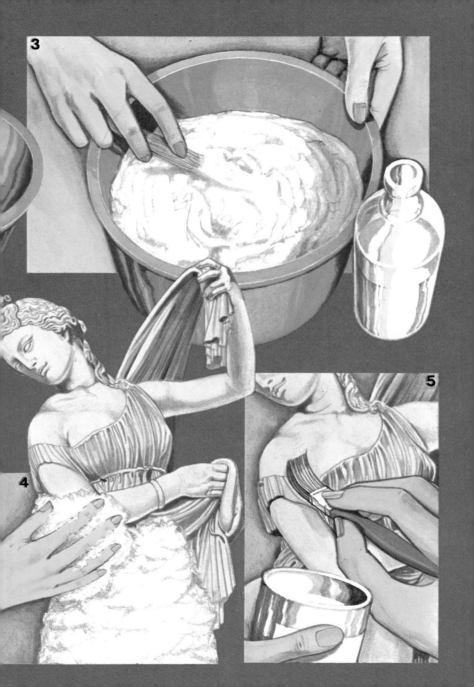

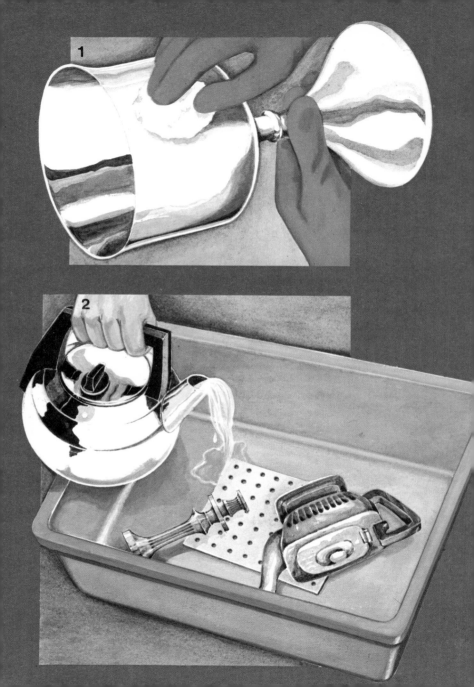

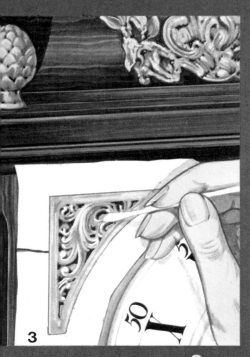

PLATE 11

Silver is surprisingly soft and great care must be taken in cleaning.

1. Electro-chemical liquids are very effective. The liquid is applied wearing rubber gloves with swabs of cotton wool and left for a few seconds. After each small area has been cleaned, it must be thoroughly rinsed, then polished with a soft, dust-free cloth.

2. Heavily tarnished silver can be cleaned by a more elaborate electro-chemical process. A plastic washing-up bowl is lined at the bottom with aluminium foil or a perforated aluminium sheet (as illustrated). The tarnished silver is placed on the aluminium, making sure that there is good contact between foil and silver. The silver is covered with a 5% solution of washing soda in hot water and left for a few seconds. It is then rinsed in tepid water, dried and polished with a soft cloth.

3. Cardboard masks are used to protect wood during the cleaning of silver, or other metal fittings in situ.

4. Silver cutlery that has parted from its handles can be repaired with a perspex-based adhesive and whiting. Jug handles need to be stronger, and epoxy resin is recommended.

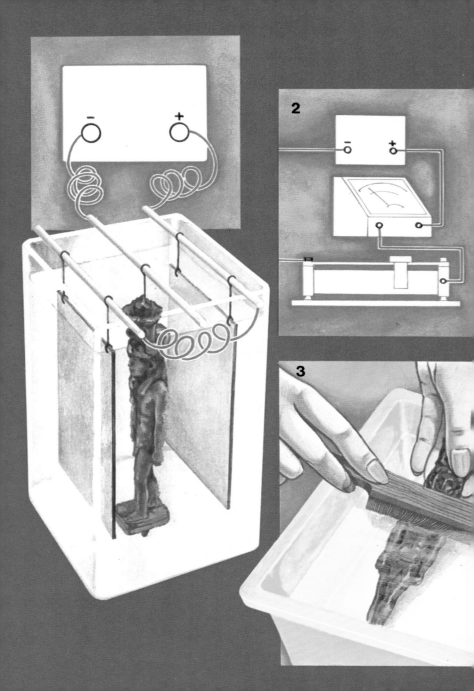

PLATE 12

Three methods of cleaning bronzes with patina or incrustation.

1. Electrolytic reduction - a treatment used when the patina or incrustation can be sacrificed. A source of direct current is needed. Into a glass or polythene container two iron sheets are suspended from metal rods, wired together as shown. Between them the object is suspended again wired as illustrated. Into the tank is placed a 2% solution of caustic soda until it covers the object by 5cms, taking precautions that it does not touch the metal rods. The current is switched on. The process will be complete by a free flow of gas at the cathode (the object).

2. Source of power controlled by a variable resistance. Batteries and accumulators may be used.

3. After electrolytic treatment, the object should be thoroughly soaked, rinsed in distilled water to eliminate all traces of the electrolyte, and brushed to remove any loose corrosive products. It must then be thoroughly dried.

Cleaning bronzes when patina must be preserved.

4. The bronze is soaked in a 5% solution of sodium sesquicarbonate made with distilled water. The process may take some weeks during which time the solution will need changing at regular intervals. Each time it is changed the bronze can be gently rubbed or brushed. When finished it must be washed and brushed (3).

5. Removing incrustation by careful picking with a needle.

6. Mechanical picking with a needle. *i)* Correct angle at edge of oxide. *ii)* Danger - needle angle correct but position liable to fracture metal as well as oxide. *iii)* Incorrect.

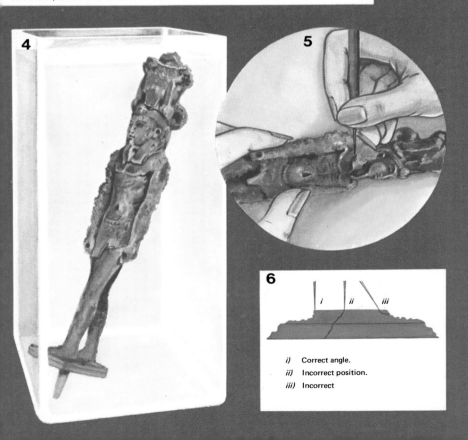

4

5

6

i) Correct angle.

ii) Incorrect position.

iii) Incorrect

PLATE 13

Removing modern gold paint from antique Chinese bronze. Gold paint is quite often found on old bronzes where attempt has been made to "restore" the gilt appearance that has disappeared with the passage of time. An expert opinion the age of the bronze should be sought before the process is attempted for *i)* the gilt might be original *ii)* the piece might modern and the gilt an important part of its appearance.

1. A tiny inconspicuous area of the bronze is first tested by applying a little water based (preferable to solvent based) pai stripper. This should not come in contact with the skin. As soon as the stripper has done its work (which may be onl few seconds) its action is halted, before it can eat into the bronze, by dabbing the area with a wet cotton wool swab. T area is then washed under running water to remove all traces of stripper and examined.

2. Providing all is satisfactory, the removal of the paint can continue, working only on an area of a few square centimet & at a time, halting the action of the stripper quickly and then thoroughly flooding the surface with water. Great care m

3. be taken to remove only the modern paint. *Traces of old gilt, and the base coats to which it was applied must be le intact as well as the dulled surface of the metal.* The process must be halted if these are being damaged.

4. Once the paint has been removed the bronze must be thoroughly rinsed under running water. It must then be thorough dried in a warm dry atmosphere for several days. When absolutely dry the surface can be protected with a very spar coat of microcrystalline wax.

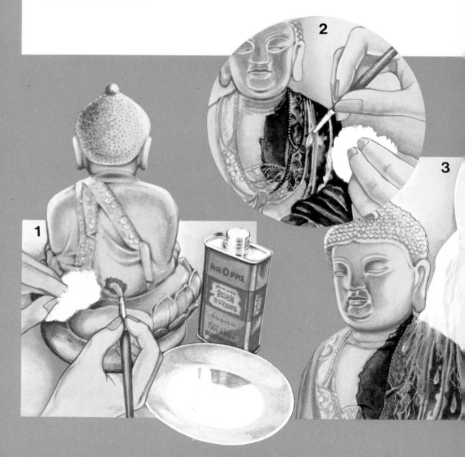

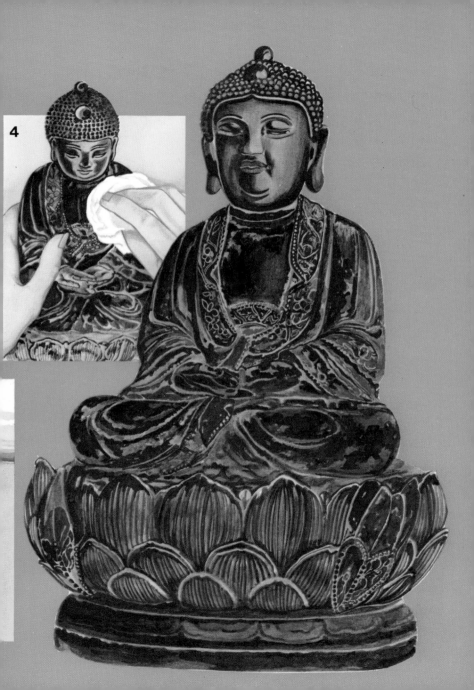

4

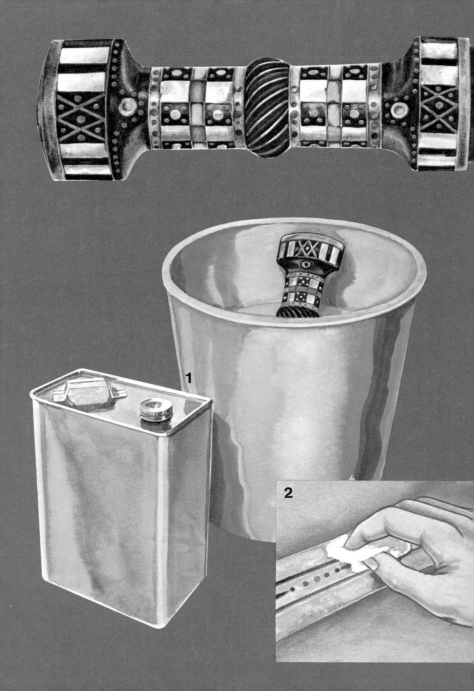

1

2

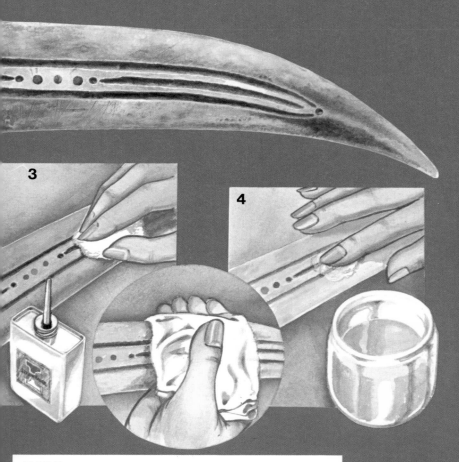

3

4

PLATE 14

The greatest enemy of iron and steel is damp. When the relative humidity is high, moisture can so easily condense onto cold surfaces, such as arms and armour - causing oxidation or rusting. Where rust occurs it must be quickly removed before the surface of the object becomes pitted.

1. Rusted dagger is soaked in paraffin (kerosine) to soften the rust.

2. Paraffin (kerosine) is then rubbed on patches with cloth. Stubborn patches should be rubbed with worn wet and dry paper. Great care must be taken not to overclean the spot or any of the surrounding areas.

3. After gently rubbing away the rust, all the paraffin (kerosine) must be completely cleaned away and replaced by lubricating oil, while continuing to bring up the surface with a clean soft cloth.

4. After treatment the surface may be protected with a minute coating of micro-crystalline wax.

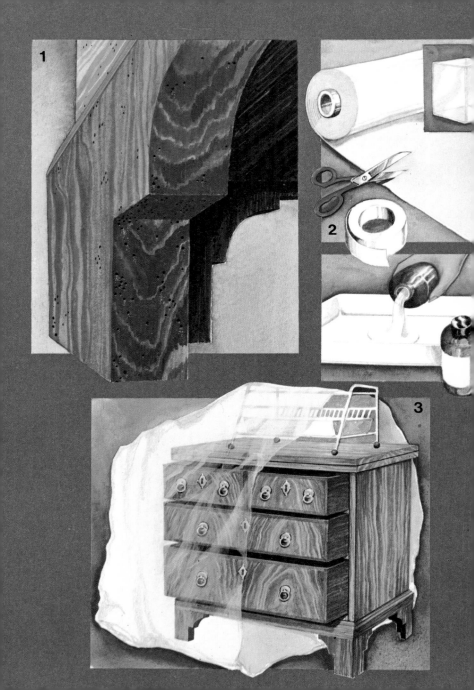

PLATE 15

Insect pests are a great enemy of furniture and wood-work. Once infestation is discovered, the object must be isolated and treated as soon as possible.

1. The presence of fresh looking worm holes with sharp edges and with wood dust around the edges or on the floor.

2. A polythene tent can be made from sheet polythene and adhesive tape.

3. Heavy vapour carbon disulphide can be used with safety for fumigation providing care and common-sense are used. A polythene tent is made and a dish of the fumigation liquid placed inside. The tent is quickly sealed and left for 24 hours after which the process is repeated.

4. Small objects like clock cases can be treated in biscuit tins.

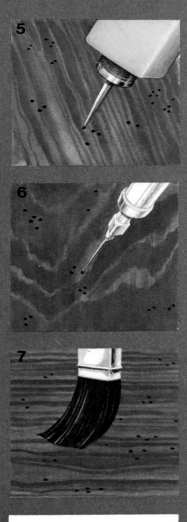

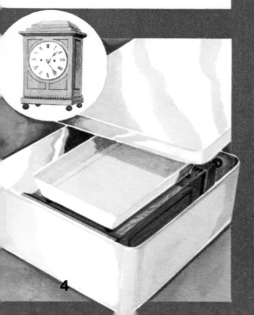

5, 6 & 7.

Commercial woodworm killer applied by the nozzle of the container, hypodermic needle, or brush.

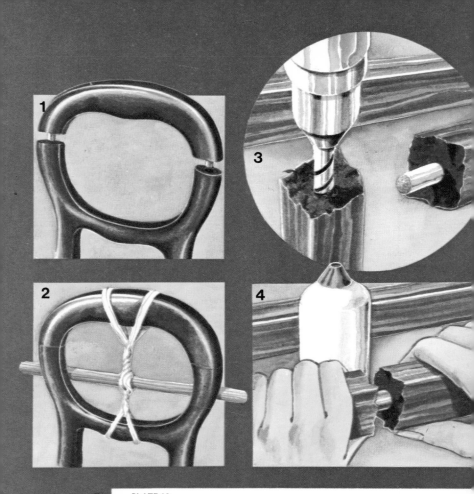

PLATE 16

Repairs to furniture.

1. Broken joints or parted dowelling may be repaired using PVA emulsion or similar commercial woodworking adhesive. The joint is thoroughly cleaned, lightly sanded, and adhesive applied to one edge.

2. The two surfaces to be joined can usually be held together while the adhesive is curing by a tourniquet system using bandages and a wooden batten, taking care to protect the surface.

3. A broken member being drilled for insertion of a wooden dowel.

4. The two surfaces being brought together after dowelling (see 1).

5. Horizontal movement of frames can be rectified by fixing wedges at the corners out of sight.

6. Wedges to eliminate vertical movement, these must be well finished as they will be visible.

7. A tourniquet system in use.

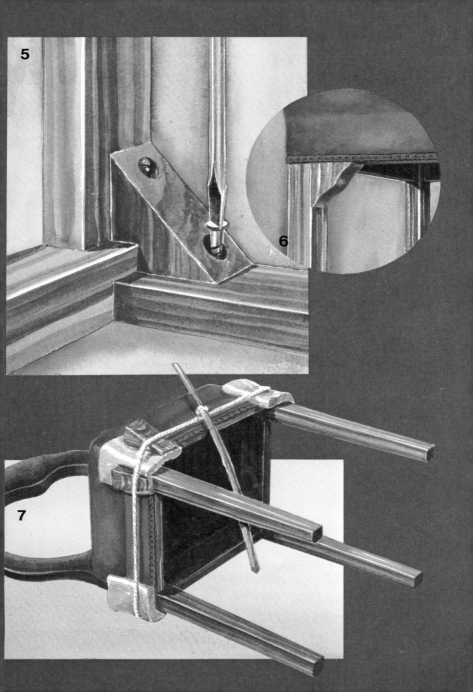

PLATE 17

Cleaning and Polishing Furniture

Cleaning grime and accummula[ted] dust from furniture can be achieved [by] the cautious use of a mixture of c[ne] part linseed oil, one part white vineg[ar] one part turpentine and a quarter p[art] of methylated spirit, vigorous[ly] shaken together before use. C[are] should be taken not to rub the gri[me] back into the wood.

For day to day care of fine furnit[ure] the best polish is a microcrystall[ine] wax, which if used sparingly has t[he] advantage of not only giving a f[ine] finish, but also cleaning and protect[ing] both wood, leather and any me[tal] additions. Once rubbed in with a s[oft] cloth it is left for a while bef[ore] buffing.

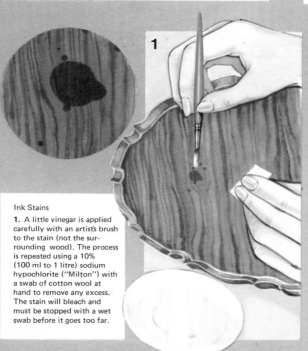

Ink Stains

1. A little vinegar is applied carefully with an artist's brush to the stain (not the surrounding wood). The process is repeated using a 10% (100 ml to 1 litre) sodium hypochlorite ("Milton") with a swab of cotton wool at hand to remove any excess. The stain will bleach and must be stopped with a wet swab before it goes too far.

Water Marks

2. White water marks caused by condensed moisture may respond simply to gentle rubbing around the stain with linseed oil on the finger. Any excess oil should be removed before repolishing.

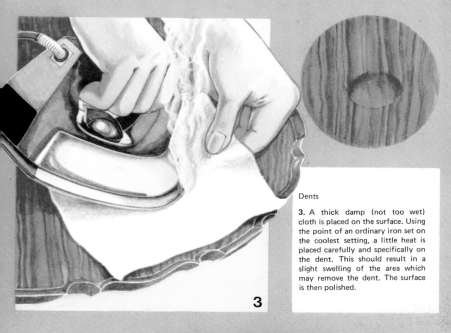

Dents

3. A thick damp (not too wet) cloth is placed on the surface. Using the point of an ordinary iron set on the coolest setting, a little heat is placed carefully and specifically on the dent. This should result in a slight swelling of the area which may remove the dent. The surface is then polished.

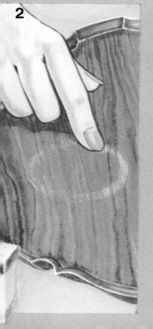

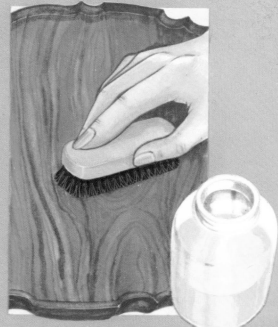

1

2

3

PLATE 18
Repair of Gesso and Lacquer Furniture

1. A mixture of gesso (see text) or cellulose filler is inserted into the damaged area which has already been cleaned and dampened. Care is taken to ensure that the repair is flat & smooth.

2. The surface is rubbed carefully with the finest abrasive paper to ensure a perfectly smooth and flat surface.

3. After sealing and applying a grey ground the repair is painted to match the lacquer using techniques used in the repair of pottery and porcelain.

4. Gesso covered frames can be repaired with cellulose filler. After moistening and applying a thin layer of filler of the consistency of water-colour paint, cellulose filler putty is pressed into position with a palette knife.

5. Modelling is finished with a wet paint brush.

6. Fine details are carved with a scalpel.

7. The finished repair is painted with burnt umber prior to gilding.

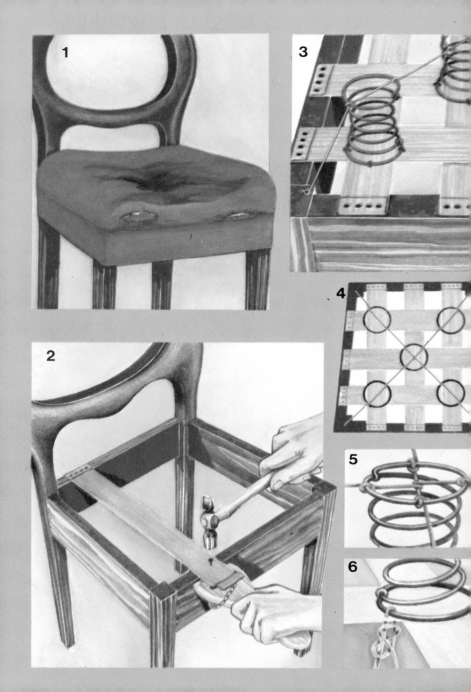

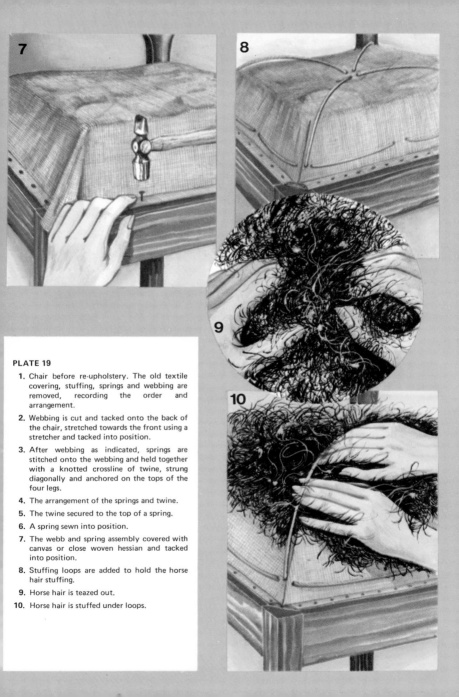

PLATE 19

1. Chair before re-upholstery. The old textile covering, stuffing, springs and webbing are removed, recording the order and arrangement.

2. Webbing is cut and tacked onto the back of the chair, stretched towards the front using a stretcher and tacked into position.

3. After webbing as indicated, springs are stitched onto the webbing and held together with a knotted crossline of twine, strung diagonally and anchored on the tops of the four legs.

4. The arrangement of the springs and twine.

5. The twine secured to the top of a spring.

6. A spring sewn into position.

7. The webb and spring assembly covered with canvas or close woven hessian and tacked into position.

8. Stuffing loops are added to hold the horse hair stuffing.

9. Horse hair is teazed out.

10. Horse hair is stuffed under loops.

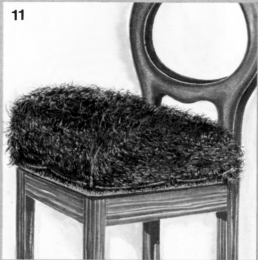

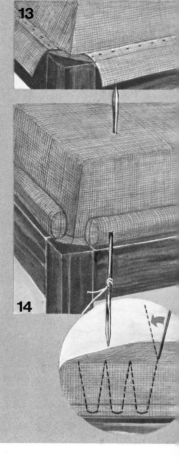

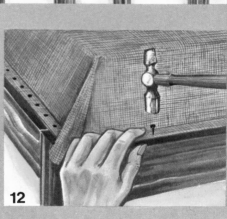

PLATE 20

11. The horse hair is stuffed under the loops until they become embedded in it. To achieve a good result there is normally more horse hair piled up in front than the back.

12. The stuffing is covered with scrim and tacked down. The scrim should not be pulled down tightly over the stuffing. The weave must also be kept straight. All bumps are removed before tacking.

13. The scrim must have overlaps which are filled with horse hair to form long firm 'sausages' along each side of the chair.

14. 'Stitching in'. The upholstery needle is inserted in the side at an angle of 45º. The needle is not pulled out, but just as the end reaches the top of the seat, the angle is shifted 45º and it is pushed out of the side of the chair.

15. After 'stitching in', stuffing loops are applied, a thin layer of horse hair, then unbleached wadding.

16. Unbleached calico is fitted.

17. The final covering is fitted.

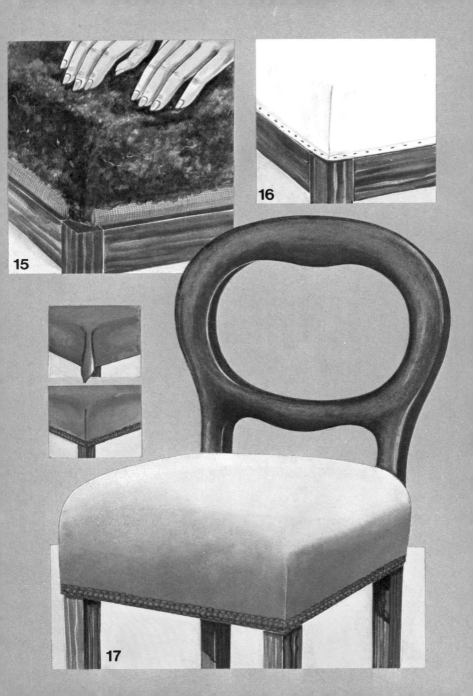

15

16

17

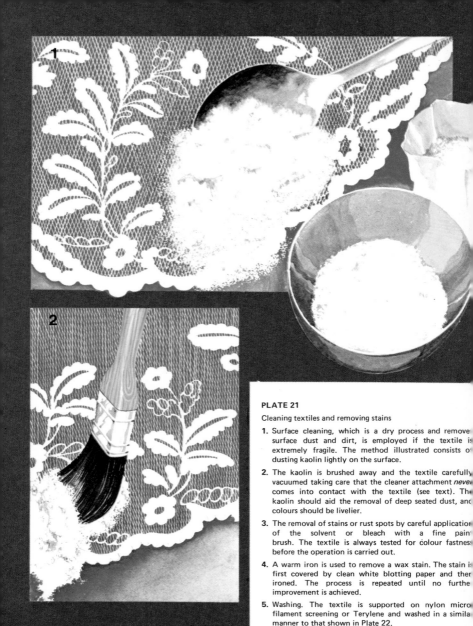

PLATE 21

Cleaning textiles and removing stains

1. Surface cleaning, which is a dry process and removes surface dust and dirt, is employed if the textile is extremely fragile. The method illustrated consists of dusting kaolin lightly on the surface.

2. The kaolin is brushed away and the textile carefully vacuumed taking care that the cleaner attachment *never* comes into contact with the textile (see text). The kaolin should aid the removal of deep seated dust, and colours should be livelier.

3. The removal of stains or rust spots by careful application of the solvent or bleach with a fine paint brush. The textile is always tested for colour fastness before the operation is carried out.

4. A warm iron is used to remove a wax stain. The stain is first covered by clean white blotting paper and then ironed. The process is repeated until no further improvement is achieved.

5. Washing. The textile is supported on nylon micro filament screening or Terylene and washed in a similar manner to that shown in Plate 22.

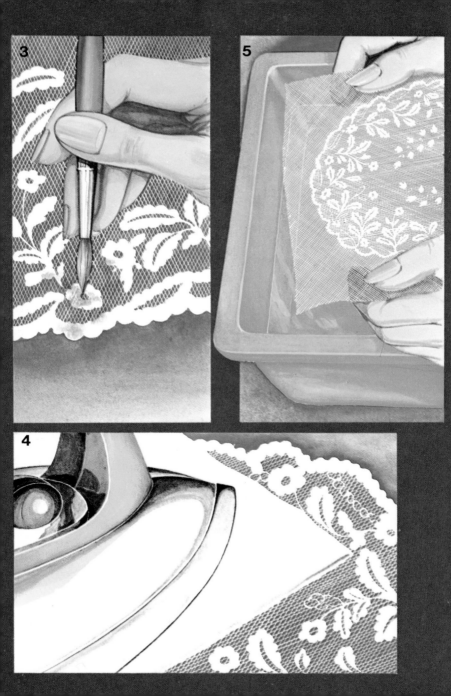

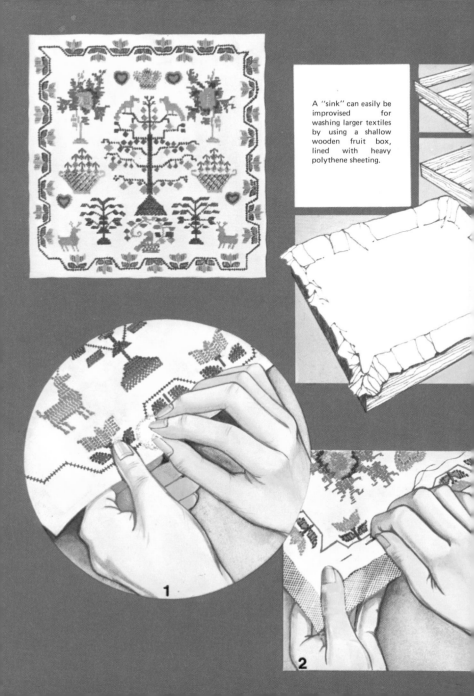

A "sink" can easily be improvised for washing larger textiles by using a shallow wooden fruit box, lined with heavy polythene sheeting.

1

2

PLATE 22

Washing antique textiles, in this case a textile sampler.

1. The sampler is first tested for colour fastness with a little tepid water on a small swab of cotton wool.

2. If the colour is fast, washing can proceed by first loosely tacking the sampler onto terylene net, to form a support during washing.

3. The sampler, supported on the terylene, is carefully lowered into the prepared washing solution.

4. After several washing and rinsing processes, the sampler is laid out on colourless towelling or blotting paper and gently pinned into shape to dry.

5. Drying can often be aided by the careful use of a warm hair-dryer.

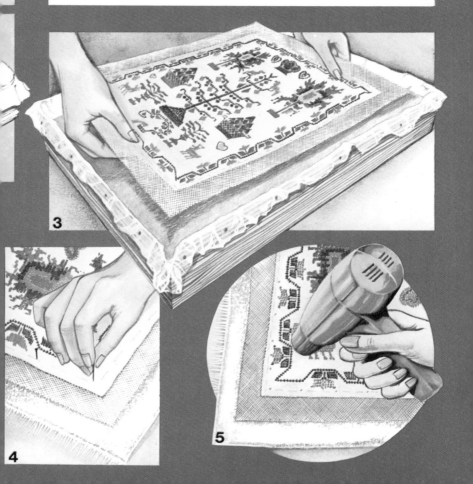

1

2

3

4

PLATE 23

Cleaning antique rugs.

Rugs and carpets must be treated with the same care as textiles. Their treatment is similar.

1. A rug should be vacuum cleaned regularly, preferably with nozzle attachments, but if these are not available or the rug is not too valuable but strong, a standard upright cleaner may be used. Cleaning should be carried out on the reverse of the rug and carried out with great care.

2. The surface should be cleaned regularly by brushing out dirt with a hand brush, always in the direction of the pile.

3. If washing is envisaged, a test must be made with a small swab of cotton wool and water to ensure that the colours are fast.

4. During washing the rug should be flat and well supported. An improvised bath can be made from a child's inflatable paddling pool. Washing is best undertaken out of doors although the procedure is similar to that of textiles.

5. After washing the rug or carpet is laid out to dry. When dry it may be brushed and if necessary vacuum cleaned.

5

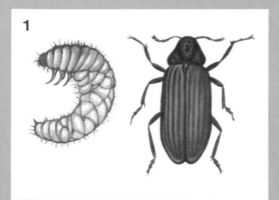

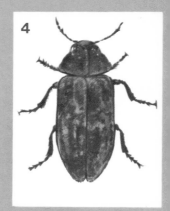

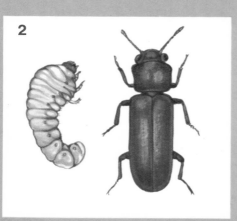

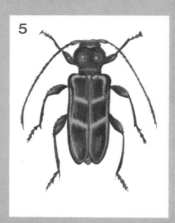

7

11

8

12

9

10

PLATE 24
Insect enemies.
1. Furniture Beetle: larva and adult. **2.** Powder Post Beetle: larva and adult. **3.** Carpet Beetle: larva (woolly bears) and adult. **4.** Death Watch Beetle: adult. **5.** House Longhorn Beetle: adult. **6.** Book Louse. **7.** Brown House Moth or False Clothes Moth: adult. **8.** White-tipped Clothes Moth or Tapestry Moth: adult. **9.** Large Pale Clothes Moth: adult. **10.** Case-bearing Clothes Moth: adult. **11.** White-shouldered House Moth: adult. **12.** Common House Moth: adult.
See Appendix for further details.

PLATE 25

Symptoms of faults found on oil paintings.

1. Sagging
2. Blistering
3. Wrinkling
4. Flaking
5. Craquelure

PLATE 26

Tightening the canvas of an oil painting.

1. To remove sagging, wedges are driven in tightly by tapping with a hammer. Any adjustment or replacement of wedges must be done with great care and caution, as damage either to the paint layer or the canvas, can result from careless or hurried work.

2. Re-stretching by replacing tacks. This may be
& necessary when no wedges are present.
3. However, it is possible that the stretcher may have to be replaced. In this case, the tacks are removed and a new stretcher made to the same dimensions. It is replaced with copper tacks.

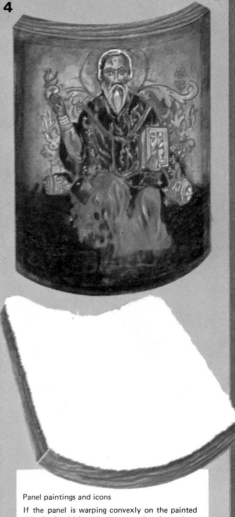

4

Panel paintings and icons

If the panel is warping convexly on the painted side, it should be taken to a cooler place where the humidity is higher than that to which it has been accustomed.

4. The painting is placed face down on a covered table. Damp sheets of colourless blotting paper are applied to the unpainted surface from time to time. Recovery is slow, usually taking several months.

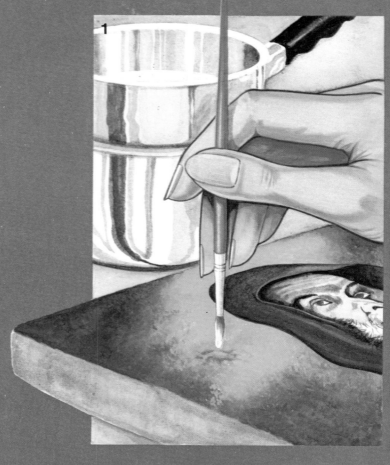

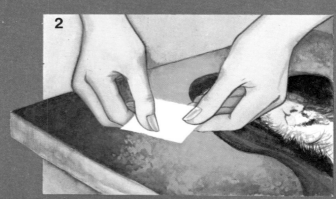

PLATE 27

Treatment of flaking and blistering.

In order to correct minor flaking of the paint layer from the ground, heat and wax are used to re-fuse the paint to the ground while flattening the paint.

A mixture of 75% natural beeswax and 25% dammar resin are thoroughly mixed and heated in a double boiler. The painting is facing upwards with the canvas supported underneath. A tiny amount of the cooled wax/resin mixture is dropped onto the flaking area.

A small piece of heat resistant silicone paper is placed over the wax to protect the paint layer. A thermostatically controlled spatula is then gently rubbed over the area causing the wax to permeate the paint. When melted, gentle pressure is exerted on the paint through the silicone paper, laying down the paint and working the wax into the cracks.

5.
When the process has been satisfactorily completed the silicone paper and any residue wax is gently removed with a little white spirit.

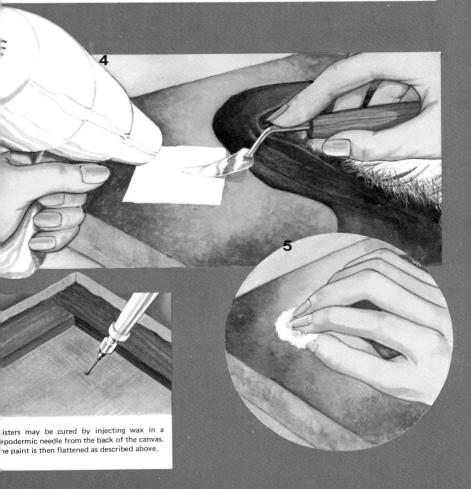

Blisters may be cured by injecting wax in a hypodermic needle from the back of the canvas. The paint is then flattened as described above.

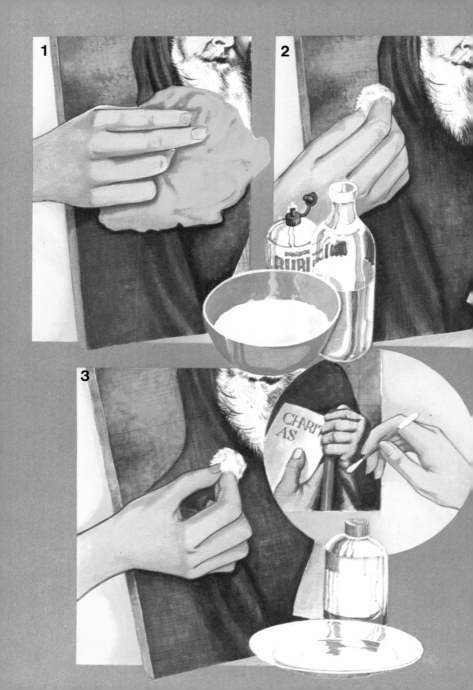

4

PLATE 28

Cleaning oil paintings sounds very simple, in fact it is far from simple, and can be very hazardous. Cleaning a painting really means removing the surface dirt and grime and then the old discoloured varnish, by using solvents that will remove the varnish without removing the paint layers underneath.

1. Surface dirt is removed with a clean soft cloth or cotton wool.

2. Surface grime is removed by using a weak solution of good quality washing-up liquid or 'Lissapol' in distilled water, applied cautiously and gently on *damp* (and only damp) pads of cotton wool, using a gentle circular motion. The pads come into contact with the surface only for as long as is necessary.

3. If de-varnishing is attempted it will be safest for the collector to use a commercial picture cleaner carefully following the manufacturers instructions. Some cleaners do not remove varnish. The preparation should only be used on small areas at a time (see text) with great caution.

4. A painting half cleaned.

5. Re-varnishing. The painting is stood upright and the varnish applied from the top.

5

1

2

a

b

PLATE 29

Repairing oriental paintings.

One of the most common ailments of oriental hanging scrolls is horizontal creasing. Ironing will not normally remove these creases and the only cure is to reinforce the back of the scroll in such a way as to prevent it bending forward, forming the crease ridge.

1. A scroll with crease across the top.

2. A pyramidal sandwiched strip of Japanese tissue is prepared as indicated: *a)* Side section. *b & c)* The two strips being pasted with starch paste. *d)* The completed strips.

3. The strips are pasted along the crease at the back of the scroll.

4. The repair is then weighed down with books or similar weighty objects.

Tears in scrolls can be mended in a similar way to European prints and reinforced at the back with Japanese tissue as indicated in **3.**

WARBLINGTON CASTLE. HANTS.

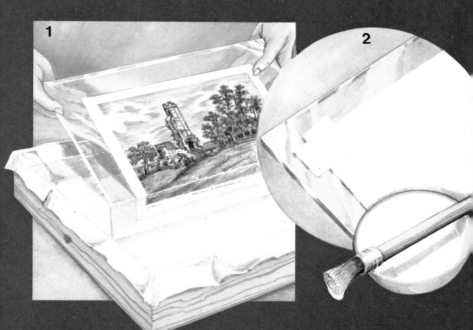

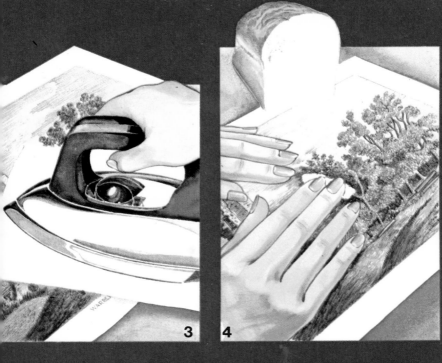

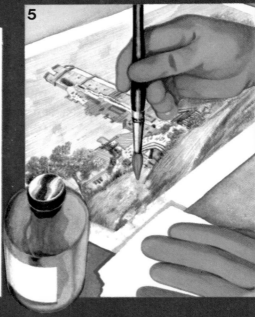

PLATE 30

Prints — cleaning, bleaching and removing stains.

The greatest enemies of prints are light, damp and dirt.

1. A print supported on a piece of plate glass being lowered into a shallow flat dish for washing. If a dish of sufficient size is not available, one may be made from wood lined with polythene.

2. When washing or bleaching has been completed, the print is pasted onto a sheet of glass with thin strips of tissue and allowed to dry. This will ensure that the print dries flat. This method is also used for removing creases.

3. Removing a wax stain by gently ironing the print between a sandwich of clean blotting paper. To remove the wax completely, the print, supported on glass, is placed in a bath of petrol and dabbed with a brush until the stain disappears.

4. Cleaning a print with day old bread.

5. Removing stains by the local application of a bleaching solution.

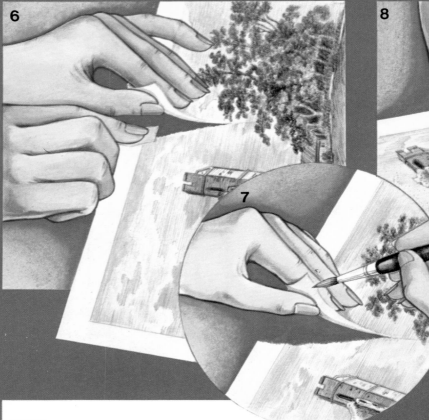

PLATE 31

6. The two edges of a cut (tears do not generally need this treatment) are carefully roughened with wet and dry paper before being welded together.

7. Once the quality of the join has been determined a little starch paste is applied to the tear with a very fine brush from the back of the print.

8. The two edges of the tear are gently worked back together, taking care not to further damage the delicate damp paper or cause it to tear. After wiping away excess paste, the print can be covered with blotting paper and sandwiched between another sheet of glass to dry.

9. Chamfering the edge of a patch which is used to hold the torn edge together from the back of the print.

10. Pasting the patch with starch paste.

11. The patch is applied to the print by holding it in such a way that one edge is in position, just touching the print. The patch is then slowly and systematically lowered and smoothed completely flat and free from air bubbles, with the aid of a swab of cotton wool.

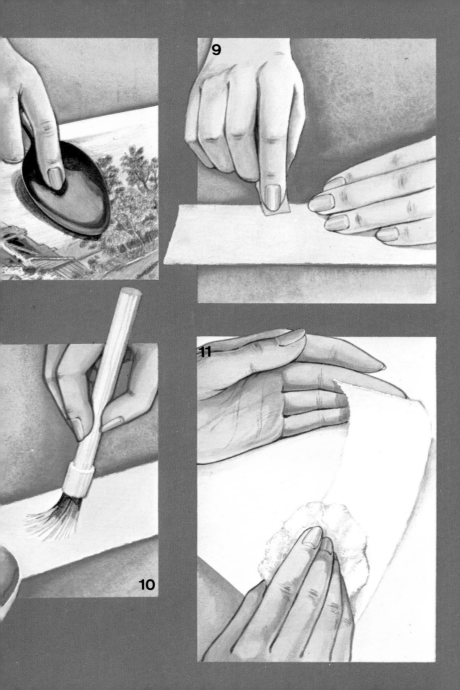

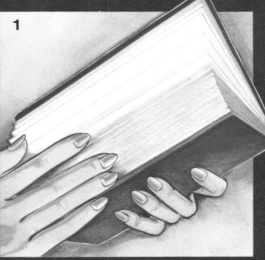

1

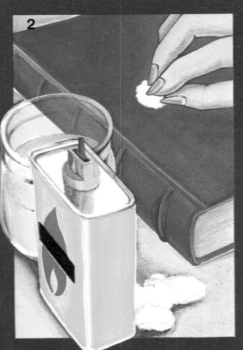

2

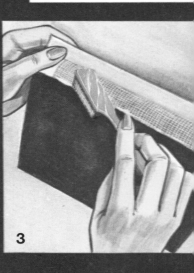

3

PLATE 32

Handling and repairing books.

1. How to hold an antiquarium book. Trea[t]
as a fragile friend. Both old and new boo[ks]
need correct handling. A book is made [of]
fragile and perishable materials a[nd]
deserves respect. Always cradle the spine [of]
a book in the palm of the hand, either ri[ght]
or left. Open it gently — do not lay it do[wn]
and press it flat.

2. Leather bindings can be cleaned [by]
washing with pure soap and the v[ery]
minimum amount of water. Some sta[ins]
may be removed by swabbing with pet[rol]
or white spirit. Old leather bindings lo[se]
their lubricants. These can be replaced [by]
treating with commercial leather prese[rv-]
atives or preferably with BM leat[her]
dressing (formula in appendix).

3. Cleaning a damaged spine prior to rec[on-]
struction.

4. The spine is strengthened by building [it]
with PVA emulsion adhesive cured w[ith]
warm air from a hair dryer. After buil[ding]
up with several coats, a final coat is app[lied]
and the spine replaced.

5. The spine held in position with string a[nd]
protectors.

6. Damaged corners can be built up with t[hin]
cardboard.

7. Damaged corner being recovered.

8. The repaired and recovered corner be[ing]
pasted under the end papers.

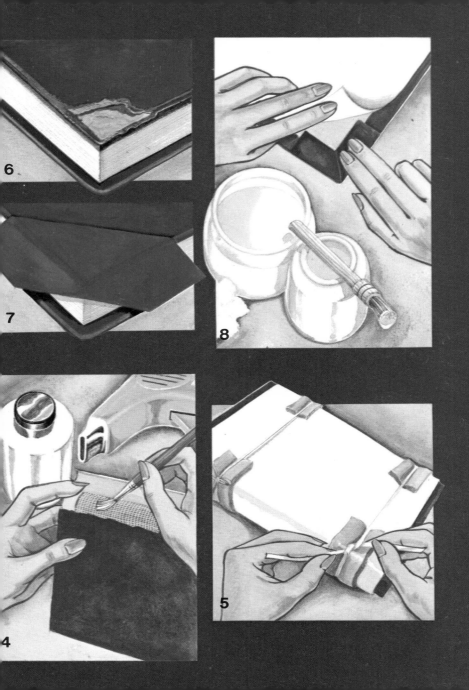

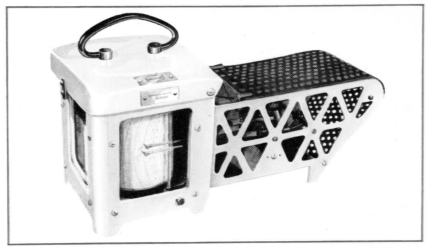

PLATE 33

Every serious collector should invest in some means of recording the temperature and relative humidity of the environment in which his collection is stored or displayed. This should be plotted over a period of months. With experimentation he will probably find that areas of his home or even certain areas of a room maintain a more even temperature than others. These should prove the best areas for his collection.

Several instruments are illustrated here. **1)** Mechanical drum type of recording hygrometer suitable for museums or collections where continuous records are needed. **2)** Static wet and dry bulb thermometer used in conjunction with hygrometric tables. **3)** Whirling hygrometer, in reality mobile wet and dry bulb thermometers. **4)** The most convenient form of instrument for the collector, the dial hygrometer.

7 *Upholstery*

More often than not the most vulnerable part of a chair is the upholstery. Constant use strains the fabric and wears the edges. It is therefore not surprising to learn that a chair may have been upholstered a number of times during its life. Whereas a few years ago it was not a particularly expensive operation to have a chair or set of chairs re-upholstered, today it is another matter. It may also be difficult to actually find someone capable and willing to undertake the job—provided that you can afford it. These are all reasons for undertaking the re-upholstery yourself, but let it be stated at this stage although it may appear simple, there are so many little things that can go wrong that you would be well advised to have the work carried out professionally if you can. If for some reason you cannot, then the following brief description of the re-upholstering of a dining chair will help. Before going ahead, do think carefully and study the colour illustrations to be sure that you feel confident to try. If the chairs are particularly valuable it would be best to leave them alone until such time as they can be done by a craftsman.

The first operation consists simply of removing the old textile covering, stuffing, springs and webbing. Do this carefully, recording the order and arrangement so that you will be able to imitate it on your own.

Having removed all the old upholstery take the frame of the chair and place it on a table of a convenient working height. Webbing is then cut and tacked on to the back of the chair and stretched towards the front using a stretcher as in plate 19/2. After

having completed the back to front row of webbing, a row is woven from side to side in the same manner.

On to the web foundation the springs are replaced (if they are still serviceable) or new springs of the same size used. The arrangement should follow that originally used, but an idea of layout may be had by consulting the colour illustration. The springs are stitched on to the webbing and held together by a knotted cross line of twine which is strung diagonally and anchored in the tops of the four legs. Care must be taken to ensure that the springs are aligned correctly otherwise the upholstery will develop the wrong shape—looking unsightly as well as being uncomfortable.

The webbing and springs are now covered with canvas or close-woven hessian. This covering should overlap by at least 2·5 cm. This overlap should be folded inwards over itself, before tacking. After this the springs are stitched to the covering just as they were stitched to the webbing.

On to this assembly a series of large stuffing loops are sewn, both in a criss-cross manner on the top and along the sides. Each diagonal and side should be formed of two big loose stitches. See plate 19/8. Each stitch should be separate from the other and secured indirectly. This is the basis on to which the horse-hair stuffing is applied.

Before actually applying the horse hair, tease it out so that its volume is increased and so that its 'spring' is emphasised. Now comes the tricky part, an operation that looks quite simple but is in fact quite difficult to do properly. The horse-hair is stuffed under and between the loops a little at a time, until they become embedded in it. Keep trying until the horse hair is spread evenly and tight. After you are satisfied with the result, the stuffing is covered with scrim in the same way as the hessian or canvas was applied in the previous operation. A point to note at this stage is that to achieve a good result there is normally more horse hair piled up in front than at the back; this is pulled down into shape with the scrim covering. The colour illustration uses a certain amount of artist's licence to emphasise the application of the horse-hair; the exact amount will be determined by each individual

chair's requirement. In reality the horse hair will flop very much more than is shown in the illustration. The scrim should not be pulled down tight over the stuffing; the weave must also, as far as possible, be kept straight. Before tacking make sure it does not look bumpy, if it does, push in a regulator or stick to remove the bumps. A point to note is the way the scrim is applied. It should be tacked along one edge and laid over the top and held down in such a way that the horse-hair is pushed into it.

The scrim covering must be larger than the hessian or canvas with sufficient overlap to apply rolls (if necessary). After securing the covering with tacks, the extra flaps (plate 20/13) are filled with horse-hair and pulled to form long, firm 'sausages' along each side of the chair. These are sewn on to the scrim. (Plate 20/14.)

The next process is difficult but essential. Using a large upholstery needle, the stuffing is 'stitched in'. The process is difficult to describe and can best be understood by referring to the colour illustration. The double-ended upholstery needle is inserted from the side (through the rolls, if present) to the seat at an angle of 45°. The needle should not be pulled out, but just as the end of the needle reaches the top of the seat, the angle should be shifted 45° diagonally opposite and pushed down and out of the side of the chair, a short distance away from where the needle was inserted. A series of stitches should be made around the chair about 4 cm in from the edge. Another series may be added about 3 cm inside this. Each series of stitches should be above the other at the side. It should be pointed out there are a number of techniques used in upholstery and the method described may be different to that originally used on the chair.

When stitching each 'up and down' the thread should be wrapped around the needle several times after the needle is removed and then pulled tight. The needle can then be inserted about 5 cm along and the operation begun again. This process, together with that of making rolls, is almost impossible to describe accurately in words, only experience and reference to the illustrations will help.

After 'stitching in', a further series of stuffing loops can be

applied and a thin layer of hair added. On to this add a layer of unbleached wadding which has been cut to the size of the seat. The seat should then be covered with unbleached calico. This last layer of cloth before the final covering should be applied with care, making sure that there are no folds and that the tension is correct. When smoothing, always start at the centre of the seat and stroke outwards.

The final covering can then be applied. In the case of the chair illustrated, a plush velvet was used. The fabric should be about 5 cm longer all round than actually required. The exact shape should have been worked out at the earlier stage of calico covering, when the pattern could be perfected.

After centring the fabric on the seat, it can be smoothed down and fixed into position temporarily by using upholsterers' skewers. It is far better to take a long time getting everything right before tacking, as this is what will be seen. Take care with the corners, making sure that the overlap is pushed inwards neatly, as in the illustration. After tacking, the tacks may be covered with a braid or alternatively upholsterers' studs may be used.

When upholstering for the first time always use a plain fabric—it is easier. When upholstering a series of chairs make sure that the pile all falls in the same direction otherwise they will appear to be different shades, even though the fabric may come from the same roll. This is due to the light being reflected at different angles.

Some Edwardian chairs have very thin upholstery. In these cases follow the style of the original upholstery as closely as possible, using the technique described above. This applies to any variation that you may find that you may wish to retain. Never use foam or rubber—the result is a very poor imitation.

8 Textiles and Carpets

Textiles and carpets can be made of four groups of fibres: (1) natural fibres of animal origin, i.e. wool and silk, (2) natural fibres of vegetable origin, i.e. cotton, jute and linen, (3) man-made synthetic fibres, (4) a mixture of different fibres. It is the natural fibres that concern us most in this chapter, as they are far more vulnerable and delicate, and are most likely to come under the care of the collector.

Animal fibres contain keratin, which is a nitrogenous compound present mostly in horny tissue such as nails and also in hair. When burnt, animal fibres, due to the presence of keratin, can have the characteristic smell of burnt hair. Vegetable fibres, on the other hand, are made up of cellulose, which when burnt has a smell characteristic of burnt paper.

It is very important when caring for textiles of all kinds that the material from which they are made, i.e. animal, vegetable, synthetic or mixture, is identified, as this will affect any treatment. Experience in recognising fibres can soon be gained by the simple burning test on worthless samples, the use of a lens, and by further reading.

Textiles are prone to damage from all sources. Damp, heat and poor ventilation can promote mould growth, while exposure to heat and light can cause the fibres to become dry and brittle. Pollution by gases or contact with dust and dirt, which may contain pollutants such as sulphur dioxide (easily converted to sulphurous acid and then oxidised to form sulphuric acid), can result in an overall weakening of the fibres, known as 'tendering'. This

overall weakening can so often lead to unsightly tears and fraying. The presence of dust and grit can physically damage the fibres by causing minute cuts, particularly in the case of carpets. Added to this is the problem of household pests, such as the larvae of the clothes moth and carpet beetle who love tasty textiles, particularly when they are dirty or contain animal fibres.

Having said this it will become clear that textiles must be kept clean and stored carefully in order to reduce the risk of tendering by dust and pollution, as well as reducing their attractiveness to household pests and the likelihood of physical damage. Textiles must always be carefully stored. If they are not in storage, exposure to heat, light, damp and bad ventilation must be avoided.

A good supply of acid-free tissue paper is essential for storing textiles. Clean textiles should be stored, right side outermost as flat as possible, without creases, and in the case of garments, should be as near as possible in the shape they are when worn. Folds and creases should be avoided where possible as these tend to weaken the fibres. However, if folding is unavoidable, sheets of acid-free tissue paper should be placed between the loose folds, the position of which should be altered from time to time.

Large textiles are best stored loosely rolled in lots of tissue, inside and outside, and carefully labelled on the outside so that the object can be identified without unnecessary disturbance. Antique garments are best stored on dummies or hung on coat-hangers that are well padded, like a dummy, to avoid any distortion. Tissue paper should be used to pad garments into the shape they would have when worn, taking care to counteract any strain, e.g. applied to a bodice when supporting a skirt, by sewing tapes on the inside of the garment and attaching these to the hanger.

Dolls' clothes are best stored on dolls, again with careful padding to prevent unnecessary creases, and the dolls stored in boxes and carefully marked for identification. Likewise gloves and handbags, etc., should be padded. Labels of any kind should not be stuck or pinned to the actual textile, only to the outside of the packing material.

134

Any finishes, such as starch, should be removed by washing (see below) before the textile is stored, as these could be an instant attraction to moulds and household pests. If starching is needed when an object comes out of storage, this must be re-applied preferably using the 'old-fashioned' starch, but must again be removed before storing.

Having wrapped the textile in plenty of acid-free tissue paper it is important that it remains free from contamination by dust. This can ideally be achieved by wrapping in clean calico bags, which in the case of garments on dummies, should be closed at the top and open at the bottom. Polythene bags and sheeting should, in general, be avoided as they can unknowingly harbour moisture and encourage the growth of mould. However, polythene can have its place, only if carefully and regularly checked, especially in industrial atmospheres where the calico mentioned above would afford little protection against industrial grime that seems to penetrate everything except carefully sealed polythene.

Although moth repellents are available, their use tends to lead to an attitude of unjustified complacency, for they are not always wholly effective. The most effective deterrent against pests is careful and regular checking of the items in your care.

Cleaning

Before an old textile can be cleaned, certain questions about it have to be answered:

(1) What is the nature, age and value of the textile? If necessary an expert opinion should be sought.

(2) Does the answer to (1) justify expert attention?

(3) What is the nature of the fibres, i.e. animal, vegetable, synthetic, or a mixture?

(4) Which are the weft and which the warp threads and are they made of the same fibre?

(5) Is there any applied decoration such as embroidery, ribbons, metallic threads, etc.?

(6) What are the colours of any dyes used?

(7) Are there any selvages or frayed edges?

(8) Is there a lining or interlinings?

(9) Are there any holes, tears, frail areas or stains?

(10) Is there any stitching or stitch holes?

(11) Is the textile strong enough to be handled, or is to too frail?

There are three basic methods of cleaning old textiles:

(1) Surface cleaning, which is a dry process and removes surface dust and dirt. This is the only method that can be employed if the textile is extremely fragile.

(2) Washing, a delicate process using special products designed for use on old textiles and not commercial wash-day products. Washing is practical only in the case of textiles which are strong and do not have complications such as metallic threads, paintings, or fugitive dyestuffs.

(3) Dry cleaning. Because of the amount of solvent required and the problems that this can cause, both to the textile and the person using it, dry cleaning is not recommended.

Surface cleaning It is important to keep the surface of a textile free from dust and grime, either to prevent its deterioration (as already described), or to assertain its condition prior to washing.

The most effective form of surface cleaning is done with a vacuum cleaner attachment, which unlike ordinary brushing and dusting, actually takes away the dust. Textiles that are in a horizontal position and will attract most dust (i.e. carpets and furniture upholstery) should be frequently cleaned. Vertical textiles such as tapestries can be cleaned less frequently.

The vacuum cleaner attachment must never come into contact with the textile. Ideally, a piece of nylon monofilament screening or filtration fabric, as it is sometimes known, should be placed on the textile to protect the fibres from the sucking action of the cleaner. Investing in a metre or two (see below under Washing) of nylon microfilament screening is certainly worthwhile, but if this is not possible, a piece of Terylene net can be attached to the open nozzle of the attachment. Although this is not efficient, it

is better than nothing, but care must be taken that the attachment does not come into contact with the textile, but is held a few centimetres from the surface.

When the textile is too frail to be washed, surface cleaning can be aided by the use of a small quantity of kaolin, sprinkled lightly on the surface, after first testing a small area. When carefully vacuumed away, as mentioned above, the kaolin should have aided the removal of deep-seated dust, and colours should be livelier.

Washing After surface cleaning, washing can begin on strong textiles where further cleaning is thought necessary. Washing an old textile can be a hazardous process, not only because of the unexpected problems that can arise, but also, as is the case with paper, because once wet the fibres are considerably weakened as well as heavy with water and the risk of damage is greatly increased.

It is important to answer the questions above in order to understand the problems that are likely to arise. As a general rule silk should not be washed by the amateur, as the various finishes applied to silk once washed away gives disappointing results, so expert advice should be sought. Likewise old flags and banners too, should not be washed by the amateur, for they often present problems that can be tackled only by a specialist textile conservator.

When washing old textiles it is important that they remain flat. For this reason, if the textile to be washed will not fit into the available sink or bath space, an improvised sink should be made. This can easily be done by lining a shallow wooden box of the correct size to fit the textile and about 15 cm deep with a sheet of heavy-duty polythene. If the box is fairly small the polythene can be tacked, but if large, weighing the edges down with weights will probably suffice. It will help if the box has a V cut out of one corner to aid removal of the water.

A supply of soft, tepid water will be needed for washing. If the water available is known to be hard, it can be softened in containers by adding a proprietary water softener (usually in powder

137

form) to the proportions advised on the package. It is advisable to have enough distilled water for a final rinse, the quantity will depend on the size of the textile. The washing agents used can either be Synperonic NDP, which is a detergent especially produced for washing delicate objects, or Saponaria, which is a plant extract with mild detergent properties. Synperonic NDP should be used in a 1% solution, i.e. 10 ml per litre of water, and Saponaria as instructed on the package. Commercial products designed for the family wash should not be used.

A piece of nylon monofilament screening or strong Terylene net a little larger than the textile will be needed to support the flat textile during washing, and also a flat sponge. Some brass lace pins, a quantity of white blotting paper or colourless towelling and a table or board covered with polythene and larger than the textile will be needed for drying.

Before washing any dyes present must be tested for fastness. Each one must be tested in turn by dabbing carefully with tiny pieces of colourless blotting paper moistened with tepid water. Do not introduce too much water, for if the dye bleeds it will carry the colour to other adjoining areas of the textile. This process must be carried out deliberately and efficiently so that every dye is tested.

Should any of the dyes bleed they must be fixed before washing can proceed or the textile will be ruined. In a textile where the dye is very fugitive, it is a good idea to make spot tests with the fixing solution mentioned using tiny pieces of blotting paper. In this way the strength required and the efficiency of the fixing solution can be established before the whole textile is submerged.

Fixing is achieved by immersing the whole textile exactly as described below for washing in a 5% solution of common salt. When removed from the solution each fugitive dye is fixed. Only then can washing proceed. If a garment such as a Victorian doll's cotton dress has ribbons attached, the dye of which is fugitive, it is much safer to remove these before washing the garment. Fix and wash these separately, replacing them after this is done.

If a textile has lining or interfacings, it must be removed

before washing can begin. This is washed separately and then replaced. If this is not done, any dust and dirt trapped between the lining could set up a reaction during washing and leave the textile irreversibly marked.

If there are any frayed edges or worn areas, they can be supported either on a piece of nylon monofilament screening or Terylene net somewhat larger than the area it is to support, loosely tacked into position with a fine needle and colourless thread. Care must be taken not to make the tacking too loose, but at the same time not to set up tension, if this is too tight, or damage the fibres with the needle.

With the sink or tank prepared with enough slightly warm, i.e. 38 °C (100 °F), washing solution to cover the textile, it is placed flat on to the screening or net. Holding the support and not the textile it is gently lowered into the water. Occasionally it might be advantageous, for ease of handling, to loosely tack the textile to the support, but care should be taken that this will not cause unnecessary tension when the textile is heavy with water.

Having lowered the textile into the water, a sponge is used to gently dab the water so that the suds move through the fibres. The textile should never be squeezed or rubbed or lifted without aid of the support. If the water becomes dirty very quickly the screening can be lifted out supporting the textile and the process repeated with fresh washing solution.

Once the textile is clean, it is rinsed in changes of just warm soft water until all traces of the washing agent have been rinsed away. A shampoo attachment or a hosepipe with sprinkler, if the textile is large like a carpet, can be helpful when rinsing, providing the jet of water is gentle. Ideally the final rinse should be of barely warm distilled water.

When rinsing is complete the textile is lifted out flat on the screening or net and placed on a suitable table or board covered with polythene or if possible colourless towelling to absorb the water. It is then allowed to dry flat, and should be laid out in position, right side uppermost. Brass pins are then placed vertically or at slight angles, in relevant places to ensure that the correct

position is maintained during drying. The textile can be gently patted with colourless towelling or blotting paper to remove excess water. The careful use of a slightly warm hairdryer can be helpful if conditions are damp. The textile should not be exposed to heat or strong sunlight but should wherever possible be allowed to dry naturally.

If a large textile, such as a carpet, which has probably been washed out of doors has to be moved while still wet, this is best achieved by rolling it between colourless towelling and then carrying it supported by several people. This method is also useful for speeding up the drying of heavy textiles.

Ironing old textiles should be avoided wherever possible, as the application of heat and pressure to old fabrics can cause damage. After washing or during storage, it is possible to lay the textile out in such a way as to avoid creases and minimise ironing. If used, an iron should be as lightweight as possible and set to the coolest setting.

Removal of stains The removal of any stain inevitably causes weakening of the fibres. It therefore follows that it is sometimes better to have a small stain than an area of weakened fibres, and providing the textile in question is not important or valuable, the choice of whether or not to remove a stain can be left to the individual. It should, however, be pointed out that stain removal is hardly ever one hundred per cent effective, particularly in the case of old stains whose chemical composition may have changed over the years. If it is decided to remove a stain, the following table gives an indication of suitable procedures and their application.

REMOVAL OF STAINS FROM TEXTILES

VEGETABLE FIBRE		ANIMAL FIBRE	
PERMITTED	PROHIBITED	PERMITTED	PROHIBITED
Dilute Alkalis	Acids or Alkalis	Dilute Alkalis	Strong Acids or Alkalis
Weak Chlorine Bleach	Dilute Acids	Hydrogen Peroxide	Dilute Nitric Acid
Very Hot Water			Chlorine Bleach
			Very Hot Water

		Material stained	
Nature of stain	*Cotton or linen*	*Silk*	*Wool*
1. Blue-black ink	C or JOM	EADM	EDAM
2. Copying ink	GML	GM	GM
3. Fresh oil-paint	IM	GN	GNR or IM
4. Grease	Q or R	Q or R	Q or R
5. Iron rust	FM or IAM	IAM	FM or IAM
6. Lipstick	AM	EBAM or AM	EBAM or PM
7. Marking ink	ML	BE	NQ
8. Mud	EBM	EBM	EBDM
9. Old oil-paint	K or HM	KM	KM
10. Red ink	C or BG	EAD	MGB

Chemicals which may remove stains. They should be applied in the order indicated by the letters opposite the relevant stain

A	Acetic acid (0·5 per cent)	J	Potassium permanganate (1 per cent)
B	Ammonia (0·1 per cent)		
C	Chloramine-T (fresh, 2 per cent)	K	Pyridine
		L	Sodium hydrosulphite (5 per cent) made alkaline with ammonia
D	Hydrochloric acid (2 per cent)		
E	Hydrogen peroxide (10 vols.) made alkaline with ammonia	M	Soft water (Hot)
F	Hydrofluoric acid★ (1 vol. +3 vols. water)	N	Spirit soap (BPC)
		O	Sulphurous acid
G	Methylated spirits	P	Tartaric acid (fresh, 5 per cent)
H	Morpholine		
I	Oxalic acid (1 per cent)	Q	Trichlorethylene†
		R	White spirit

★ This is a very dangerous chemical and should *never be used*. It is listed here for information only.

† Use not recommended—can damage kidneys.

9

Paintings

Paintings, that is easel paintings, i.e. those in oil or tempera on canvas or wooden panels, can be one of the most mistreated and neglected of all works of art. They are prone to attack not only from without but also from within. Perhaps it would help us understand the problems of looking after these works of art if we look briefly at their make up.

A painting is made up of layers, one on top of the other. First, there is the support, which can be either a wooden panel or canvas which can be woven from linen, cotton or hemp and protected by a sizing of glue. Secondly, there is the ground, which is basically an inert white substance in a glue. During the Renaissance and particularly in Italy it became popular to use a calcined gypsum or gesso and sometimes chalk as a ground for panel paintings. This was often of two layers, *gesso grosso*, which is somewhat coarse, and *gesso sottile*, which was finer. A special ground called bole, in which the inert substance was a kind of clay, was often used if gold leaf was to be applied. Thirdly, comes the paint layers, made up of various coloured pigments in a binding medium which could be egg yolk or whole egg, as in the case of tempera, or drying oils. Lastly, when the paint layers were thoroughly dry, the varnish was applied. This had two functions; to give the painting a brilliance and aesthetic appeal and to protect the paint layers from contamination from the air. In a painting that is stable and in good condition all these layers are bound and fused together as a whole.

One of the most common problems with paintings, or perhaps

we should say the most commonly recognised, is the network of minute cracks which develop slowly into intersecting lines and make up a complicated network of dark lines on the painting. Known as *craquelure*, this is a natural process caused by the effect of time on the medium of the paint layer, whether oil or tempera. *Craquelure* can also be caused by the artist's bad technique, in that the layers of paint were not allowed to dry thoroughly before another was applied. This is known as *youth craquelure*. Another cause of *craquelure* was a faulty choice of materials, such as asphaltum or bitumen, which, as they are somewhat soluble in the medium, dry badly; this is known as *alligatoring*. Provided the painting has *craquelure* and not actual cracks or crevices there is no need for alarm, as it is generally accepted as part of the ageing process of the medium and is not likely to give rise to instability of the painting. It should perhaps be mentioned that *craquelure* is also a symptom in the ageing of varnish which is usually brown and discoloured, and under these circumstances is no indication of age of the painting. For many years unscrupulous dealers all over the world have been zealous in the use of 'ageing varnish' and 'cracking varnish'.

Certain pigments used in oil and tempera painting are particularly vulnerable to chemical changes, in particular ultramarine and copper resinate green. Ultramarine tends to become a mottled white, probably due to the action of acid, and greens tend to turn a dirty brown, due to the presence of alkalis. Both these conditions are probably due to bad cleaning methods in the past, i.e. soap and ammonia are alkali.

Soot is particularly damaging as it is greasy and contains sulphur dioxide which is readily converted into sulphuric acid by the catalytic action of iron and which, if allowed to penetrate the painting, will weaken anything it comes into contact with, varnish, paint and particularly canvas. Dust too is potentially dangerous, and should not be allowed to accumulate. Dusting should be done with great care with a clean piece of cotton wool, and not a duster that has been used elsewhere and is full of invisible dust and grit that can so easily cause damage.

As an oil painting gets older it gets darker and less translucent due to a decrease in the light absorption qualities, and therefore darkening, as the oil medium in the paint layers ages. This is irreversible in oil paintings but does not apply to those in tempera. Having said this it should be clear that the practice of liberally 'soaking' an oil painting with linseed oil in an attempt to improve it is certainly not a good idea as this will only accelerate the darkening process. This darkening is also increased if an oil painting is kept under dull conditions and therefore oil paintings should be exposed to gentle and even daylight.

Generally speaking most varnishes also deteriorate with age, blooming, yellowing and becoming somewhat brittle. This process is accelerated if the painting is exposed to bright sunlight, which should therefore be avoided.

Having talked about the nature of paintings themselves and the dangers from within, let us consider the danger from without. As with all works of art, temperature and humidity probably play the most important role in the well-being or otherwise of paintings on canvas or panel, whether they be in the home or in the art gallery. Variation is the enemy, so stability must at all times be maintained. The ideal temperature for paintings is approximately 17 °C (63 °F) and a relative humidity of 58% (see Introduction). These conditions are ideal and it is obvious that what is practical in an art gallery or museum is not practical in the home. Central heating is often decried in respect of antiques, but although it does little for the problems of humidity, at least the temperature is kept constant with this form of heating. The danger comes when it is suddenly switched on and then off in the autumn and spring. Having said this, perhaps we could summarise and define the ideal conditions for keeping paintings in the home.

Wherever possible easel paintings should be varnished, and provided there is no evidence of damp or mould growth, be glazed, framed and hung on a wall in good, even daylight, avoiding direct sunlight and draughty positions. The temperature should be kept as constant and near to 17 °C (63 °F) as possible. The

relative humidity should be kept as constant and near to 58% as possible. If artificial light is used it should be remembered that an ordinary light bulb is less harmful than fluorescent lighting (see Introduction). If fluorescent lighting is used, care must be taken that it is of the 'warmer' type and not the bluer 'northlight' type, as the comparatively 'redder' light is likely to cause less damage. Care must also be taken that any artificial lighting is uniform over the whole painting and is not providing a source of heat liable to cause damage by raising the temperature. The paintings should be kept free of dust and dirt and along with the frame and attachments should be examined regularly for any signs of deterioration or weakness, for a great deal of damage is caused to paintings when they simply fall from their seemingly safe positions.

Paintings on Canvas

As we have seen, pigments which have oil as a binding medium are subject to deterioration as they get older, becoming brittle as the oil itself deteriorates. The paint, then being brittle, is less able to cope with even the minutest expansions and contractions brought to bear upon it by the stretchers as they respond to changes in the atmosphere. This can result in cracks or blisters to a greater or lesser degree. The canvas, too, is itself vulnerable and in our modern towns and cities is affected by atmospheric pollution, even more so than the paint layers. Sulphur dioxide from the atmosphere is readily converted into sulphuric acid which weakens the canvas, resulting in a tendency to tear. It goes without saying that a painting should always be treated with great care, for even the slightest knock can result in straining of the canvas in tiny areas, resulting in a circular cracking of the paint. Once the canvas has become frail it can no longer be an effective support to the paint layers and the possibility of calling in an expert to reline or reback the painting with a new canvas has to be considered.

Sagging It is possible that if the canvas seems to be sagging on the stretcher, particularly the corners, simply removing the painting to a warmer and less damp position may prove effective and the symptoms subside. If they do not, sagging may be due to the wooden wedges, which are used to support the corners of the stretcher and maintain the tension of the canvas, becoming loose, or missing altogether. Wedges are not always present, particularly in older paintings, but examination of the stretcher will soon reveal whether slits in the corners where the wedges are held are present. Any adjustment or replacement of the wedges must be done with great care and caution so as not to damage either the paint layers or the canvas by careless or hurried work. It is also important to take the condition of the canvas into consideration before attempting to adjust the wedges, for if it is weak, torn or brittle, any attempt at tightening will probably result in disaster, as the canvas is no longer able to be an effective support for the paint. Under these circumstances a long-term support must be found, such as relining, and expert advice should be sought.

To adjust the wedges, the painting is first laid on to a table covered with a soft, flat cloth to protect the painting. Using a small, light hammer and with a counterweight against the corner, the wedge should be loosely inserted into the slit in the stretcher, taking care not to damage the canvas. Wedges are inserted loosely in the corners as necessary and driven further uniformly to achieve the right balanced tension. The canvas should not be too tight so that it can respond as the stretcher expands or contracts with changes of humidity. Great care must be taken not to put undue stress on the canvas which could cause it to tear, particularly where it is nailed to the stretcher.

When there is provision for wedges and the canvas is in good condition, retensioning can be achieved by carefully removing the tacks attaching the canvas to the stretcher. Once the tacks are removed, the canvas can be carefully and uniformly pulled taut over the stretcher and re-attached with new copper tacks. If the canvas is not robust enough to allow tensioning in this way, the old stretcher could be replaced with a new one of the same size

and the tensioning achieved with great care by adjusting the wedges as described above.

Wrinkling Wrinkling in the paint layers is generally caused by bad technique on the part of the artist, in that one layer of paint is applied on to another that is not thoroughly dry, and by excessive use of oil in the medium. This causes the still wet underlying paint to slide and wrinkle the already dried surface paint. Wrinkling is often seen where bitumen has been used which, as mentioned earlier, can remain soluble and soft for many years. It can be temporarily halted by turning the picture the other way around, causing the wet layer to slide back into position, but this can be a temporary measure only and if the painting is of any value, expert advice should be sought.

Flaking Minor flaking of paint generally affects the paint layer only, leaving the ground itself intact. However, should flaking be severe, or be on a painting of value, expert advice should be sought.

In order to correct minor flaking of the paint layer from the ground, heat and wax are used to re-fuse paint to ground while flattening the paint layer. Although there may be advantages in removing the varnish before flattening paint, the operation can be harmful to the flaking paint, and so probably the disadvantages outweigh the advantages. A mixture of wax and resin is generally employed as the adhesive when flattening paint, although the choice of materials and their proportions is very much a question of personal preference of the restorer. Generally a mixture of 75% natural beeswax and 25% dammar resin, that has been thoroughly mixed and warmed in a double boiler, is used. After placing the painting carefully, paint uppermost, on a table and supporting the canvas from underneath, a tiny amount of the cooled wax/resin mixture is dripped on to the flaking area; over this is placed a small amount of heat-resistant silicone paper to protect the paint.

A thermostatically controlled spatula is then employed to gently move over the wax area, without applying pressure, to heat the wax and cause it to permeate the paint layer. Once the wax is melted, very gentle pressure is exerted on the paint, through the silicone paper, laying down the paint and working the wax into the cracks, fusing the paint to the ground with gentle heat. This gentle motion can be continued as the spatula is allowed to cool, making sure that paint and ground are truly bonded. When this has been satisfactorily completed the silicone paper and any residue wax is gently removed with a little white spirit.

Obviously, even such an unsophisticated piece of equipment as a thermostatically controlled spatula is not readily available, and the above process can be carried out by using a hairdryer, with the heat setting carefully regulated, and an ordinary fine artists' spatula. A note of warning here, where this equipment might suffice where flaking is only a small problem, there is no doubt that if the flaking is more than a small isolated problem or on a painting of monetary or intrinsic value, flattening paint is a job for an experienced hand with the correct equipment.

Blistering Treating blistering in paint, whether applied to canvas or wood, is similar to that of flaking in that it involves adhesive, gentle heat and slight pressure applied with a spatula. The success of the treatment will depend on the nature of the paint, whether fairly fresh, pliable or brittle. If blistering occurs on a contemporary work where the paint is fairly fresh and pliable, the method described—gentle heat and slight pressure without the use of adhesive—may be sufficient to re-fuse the paint to the ground.

Where the paint is brittle and the blister itself fairly large, it is usual to inject the blister carefully with the adhesive described above in a hypodermic syringe, preferably from the back of the canvas, or from the base of the blister, taking care not to damage the fragile dome. The paint is then flattened as described above.

In the case of painting on panel, a protective application of wax is needed to protect the blister and a fine heated needle used to

pierce the blister so that a syringe containing adhesive can be injected. Flattening and gently bonding the paint to the ground can be carried out as above.

Cleaning Cleaning an oil painting sounds a very simple operation. In fact, it is far from simple, and can be very hazardous. For it will test the skills and tax the judgement of even the experienced restorer. So much irreversible damage has been done in the past by faulty cleaning with all manner of substances, that, had they not caused so much damage, could really be quite funny. People over the years have in all seriousness set fire to paintings to burn off the varnish, scrubbed them with sandpaper, detergents and scouring powders, saturated them with almost everything imaginable and rubbed them confidently with a variety of vegetables from potatoes to onions!

Cleaning a painting really means removing the surface dirt and grime and then the old discoloured varnish by using solvents that will remove the varnish without removing or damaging the paint layers underneath. It is because the paint is so vulnerable and its retention so important that the old wives' tales mentioned above are so disastrous. Yes, they will probably remove the varnish but the damage, both visible and invisible, obvious and subtle, they cause to the delicate balance of the paint layers beneath cannot be emphasised strongly enough.

When cleaning a painting it is usual to remove the surface dirt and the old layer or layers of varnish as separate operations. Surface dirt should be carefully removed with a clean soft cloth or cotton wool. Some restorers see no harm in the removal of surface grime with a weak solution of good-quality washing-up liquid or Synperonic in distilled water, applied cautiously and gently as damp, and only damp, pads of cotton wool with gentle circular motions, ensuring that the dampness of the pad comes into contact with the surface only for as long as is necessary to remove the dirt. This method can be successful in revitalising a painting that is suffering from no more than surface dirt and grime, provided it has a good and stable varnish to protect the underlying paint

149

and that it is carried out with care and commonsense. Unvarnished paintings should not be cleaned in this way, but only by dry dusting.

It is beyond the scope of this book to suggest to the reader that he embarks upon the hazardous task of de-varnishing. As has already been mentioned in the case of paintings of any merit or value this is a job for an expert. The varnish on no two paintings is the same and therefore experience is needed in the choice of the correct solvent or mixture of solvents and their use on a particular painting. However, it might be suggested that for a painting of little or no value that would not justify an expert's time de-varnishing might be attempted by the inexperienced, by making use of a commercial picture-cleaning preparation from a reputable manufacturer of artists' materials. Your local art gallery or quality artists' supplier could be of help in this respect. It is of course vital to follow the manufacturer's instructions which could possibly be along the following lines.

The painting should be carefully removed from its frame and placed in a vertical position in a well-ventilated room with good light, that is as dust free as possible. As described above, any surface dirt should be removed carefully with a soft cloth. The preparation to be used should be shaken well. Using swabs of cotton wool or tiny sticks moistened with the preparation, a tiny area of the painting is tested, using a gentle circular action and taking care not to flood the surface of the painting. Care should be taken not to rub too hard and a careful watch kept to ensure that only varnish and not paint is being removed. If the test proves satisfactory, de-varnishing can proceed, cleaning only small areas at one time and replacing the swabs as they become dirty. If there is any evidence of paint being removed, the process must stop at once. When all the varnish has been removed, the surface can be wiped with distilled turpentine, probably the manufacturer's own is the safest, to arrest any further action of the cleaning preparation. The painting must then be left in a dust-free environment to allow the paint to once again harden, after which it can be re-varnished using a carefully chosen reputable product, depending on the

amount of gloss required, and again following the manufacturer's instructions.

Great care must be taken if the above is contemplated on a painting of this century, for as we have seen previously, certain oils and pigments can cause problems in drying and are very easily dissolved even by the gentlest solvents.

Panel Paintings

Although panel paintings or paintings on wooden panels are rare in private collections, their care and repair is worth mentioning as the general principles would apply to icons, which whether antique or not, are collected more widely.

Cracks and warps One of the most frequent problems with panel paintings is warping, particularly where there is only one painted surface. The other, being unpainted and therefore unprotected, responds to changes in humidity and temperature at a different rate to the painted surface and the unprotected side becomes concave, often irreparably. Wood is a low conductor of heat, but expands and contracts in response to moisture in the air. Not only drastic changes in humidity and temperature can cause this, direct sunlight would be enough to affect a painting considerably on a panel.

If the panel is seen to be warping, convexly on the painted side, it should be taken to a cooler place where the humidity is higher than that to which it has been accustomed. It should be placed face down on a covered table (to protect the paint surface) and any parts of the frame or backing that might be holding it, released to allow movement as it responds to humidity and temperature changes, hopefully returning to its original shape. This process might be helped by the conservative use of damp sheets of colourless blotting paper applied from time to time to the unpainted surface. Recovery is a slow process, taking several months, and is very much an emergency measure. Should the panel not respond to treatment or there be damage to the paint, expert advice should be sought.

If a painting on panel has to be removed from its usual position, due perhaps to moving or decorating, great care must be taken regarding the choice of its temporary environment, and what has previously been said about humidity and temperature taken into account.

If there is any possibility that the painting will be subjected to drier, warmer conditions, it is a wise precaution to protect the painting from the unpainted and therefore unprotected side. This can be done by covering the unpainted side with polythene, secured with sticky tape (but not on the paint surface!), in an attempt to insulate it from the sort of drying and warping described above. This single precaution can save much anxiety and damage, but of course it should be applied only while the painting is out of its usual environment and should be carefully watched in case of sweating or mould growth.

Mould on Easel Paintings

Occasionally paintings are attacked by mould growths of various kinds. Their appearance should act as a warning to the collector, for if the affected painting has been kept in its usual position, this could indicate that there are environment problems (see Introduction) and even though the mould is dealt with, there is every chance that it will recur unless the environment is improved.

First, the spores are gently brushed away, taking care not to spread them on to other objects. A 5% solution of formaldehyde can then be carefully brushed on to the affected area, in the case of painting on canvas provided the canvas has not yet been rotted. If mould occurs on the painted surface the solution should be carefully sprayed with a very fine atomiser on to the affected area, taking care not to saturate the surface.

10 *Oriental Paintings*

Oriental paintings are mounted quite differently to Western paintings. They are not framed, but instead are mounted as scrolls, either vertically, which are meant to be hung on walls, or horizontally, which are meant to be used as a form of picture book, and not put on display. It was not the custom in China or Japan to display a work of art for a long period or to clutter a room with numerous paintings. A painting was hung and displayed for only a short period after which it would be rolled up, stored and replaced by another. In this way oriental paintings suffer from the fact that they were mounted on paper backing, which was rolled and unrolled, eventually weakening, while the front of the painting, which could be either of silk or paper, was subjected to the same stress and had the additional disadvantage of having the pigments exposed to the dirt and atmosphere without protection. It will not be surprising then to learn that few old paintings are today on their original mounts or to appreciate that it was the custom to renew mounts as and when necessary.

While this works perfectly in the Far East, where there are traditional craftsmen used to carrying out this task, the collector in the West is faced with the problem of either sending his paintings to Japan, Hong Kong or Taiwan for this service or taking the conservation of his paintings in his own hands and tackling the job as best he can, which without adequate knowledge can be disastrous. At the time of writing I believe there is no one in Britain, other than myself, who undertakes the repair and remounting

of oriental paintings. The collector need not despair, for with a little commonsense combined with some of the techniques outlined in this and other chapters, he will at least be able to hold back deterioration and in many cases actually improve the appearance of a painting without remounting, which is a very skilled job and should be carried out only by an expert and therefore a description of the process would be out of place here.

In order to understand the damage and consequently the possible treatments that can be applied to rectify the damage, some description must be made of the structure of scrolls and of the mounting of oriental paintings.

A typical Japanese kakemono or hanging scroll is illustrated in the accompanying figure. The front of the scroll consists of the base cloth E and H, these may be silk or occasionally brocade or other material. Beneath this, forming a frame for the painting is a cloth rectangle, F1, F2, F3 and F4. These are made of separate strips and may all run the same way (i.e. the pattern or the weave) or may run in different directions. The painting (P) itself is pasted within the framework and may have a decorative strip of brocade, usually with gold thread, running across the top and bottom, G1 and G2. At the top of the hanging a rod, shaped in section, is pasted between the paper backing and the brocade front. The bottom roller which is round in section and larger and heavier is similarly attached. Two eye screws are attached into the centre span of the hanging rod and penetrate through two hanging brocade bands (C) which are of similar material to G1 and G2. The bottom roller may have decorative side rollers of wood or ivory (1).

The back of the scroll is usually not made up of one sheet of paper but of a number of sheets, each slightly overlapping the other. The whole of the front assembly is pasted individually to the paper backing. The paste used to mount the assembly is starch based and may be dissolved by dampening with water. Should it be necessary to remove the painting from the mount, it can be by dampening the back of the mount until it can slowly be removed or carefully rubbed away. This should **never** be done

Component parts of a Japanese kakemono.

by someone inexperienced in remounting as the chances are that the painting will be damaged beyond repair.

All the separate pieces of the cloth front, with the exception of panels G1 and G2, are carefully folded under at the edges. The cloth itself is backed on to very thin tissue. The paper used in making these scrolls is hand-made and is of a number of varieties.

The fact that the back is composed of overlapping sheets, and that together with the cloth facing there may be three or more layers, is the cause of one of the most common ailments of scrolls—horizontal creasing. This happens due to the different pattern of behaviour of the layers, causing tensions in certain areas, which when rolled and unrolled, can cause crease ridges to appear across the painting. Ironing with a warm iron will not normally remove these and the only way to do so is to reinforce the back of the scroll is such a way as to prevent the scroll bending forward forming the ridge. This can be done in the following way.

The scroll is laid face downward on a long table or flat surface and the back gently brushed clean with a soft, wide brush. A strip of Japanese tissue, about 3 cm to 5 cm wide, is cut to the width of the scroll. On to this another piece of tissue, about 2·5 cm to 2 cm wide, the width of the scroll, is pasted with starch paste so as to form a step section. When dry, this tissue sandwich is pasted with starch paste to the back of the scroll, straddling the crease, taking care to ensure that the scroll is perfectly flat and stretched out. The area so treated is then covered with protective tissue and weighted down with books or similar heavy weights. When dry the scroll may be hung or rolled.

When dealing with oriental scrolls it is important to use the correct paste and paper and if possible the correct tools as they will make the task that much easier with more chance of success. Paste should be the flour and water variety or the cold starch paste described in the chapter on Prints. The paper used to mend or reinforce should always be lighter in weight than that used to mount, care being taken to ensure that the grain falls in the same direction as the mount. Japanese tissue or a similar substitute is the best. Tools needed for working on scrolls are similar to those

described in the chapter on Prints, with the addition of a wide Chinese long-hair brush (see plate 29), a wide brushing down brush (available from paint or builders' merchants or hardware stores), car feeler gauges and a modellers' spatula. The feeler gauge should of course be spotlessly clean and be kept for this purpose only. It is used as a spatula of variable thickness to slide between papers, to insert paste, to separate or to ease down. It is an unlikely but invaluable tool. Tears and patches can be treated in a similar manner to that outlined in the chapter on Prints.

Two faults, peculiar to oriental paintings, need mentioning. One is the fact that some paintings that have been remounted a number of times may in fact be in pieces, each of which has been individually pasted down to form the whole painting. This is especially true of paintings over two hundred years old. Thus, although the painting on a scroll may outwardly appear whole and strong, under certain dry conditions, especially when subjected to central heating, the edges of the sections, and even the fabric facings, may begin to lift. In these cases a minute amount of paste on a thin spatula or feeler gauge can be inserted between the painting and the paper. The area can then be gently pressed down, weighted and left to dry. This can be most successful but care must be taken not to put too much paste on otherwise the surface of the painting may stain.

The other fault is that scrolls invariably begin to split along the edge where the fabric/paper assembly joins the top hanger or bottom roller. This should be stopped as soon as possible by reinforcing the back of the scroll with a strip of Japanese tissue. The loose strands of the fabric in the front may be laid down with a small paint brush, or spatula and paste.

Before doing any of the things mentioned above ask yourself— is it really necessary? Only if the answer is yes, and then only if you cannot possibly afford to have it done professionally or because the value of the item does not justify it, should you try any of these techniques. Without practice you could do more damage than already exists. If you get a chance to practise on a

worthless painting do so. But remember, if the painting is valuable seek advice, don't decide for yourself.

Finally a word about storage. Do not roll up scrolls too tightly. Equally, do not roll them up too loosely—both these extremes can cause damage. When rolling up a scroll never drop the end on the floor and roll up while standing over— this is very dangerous and weakens the scroll. Always make sure that the scroll is lying flat, face upward, on the floor or a table, then, with your hands equal distances from each end of the roller, gently roll it up using even pressure. When tying the roll do not put any pressure that will dig in and mark the painting. Make it firm but not tight. With scrolls that have hanging strips (C) these should not be rolled in with the scroll, but should be folded as indicated in the diagram. If this is not done tension will cause damage.

11 *Prints*

Prints are great fun to repair and restore, for no two prints have the same problems, are made from the same paper, have the same stains or are in the same condition. Fortunately, there are still examples of non-oriental prints that can be bought fairly cheaply for the purpose of experimentation in the processes mentioned below, and perhaps more important, practice in the techniques of handling a material as delicate as paper. The same dexterity will be needed when restoring oriental prints, although inexpensive examples are more difficult to obtain (and of course indentify) for the purpose of experimentation. It should be remembered that both the paper and pigments are generally more delicate in oriental prints, and their treatment should be regarded as more specialised.

Even when the collector feels himself familiar with the basic methods of restoring prints, it is always essential to be sure of the importance and value of a piece in his collection before contemplating any work on it. Work on valuable items should be left to a professional restorer. Any work undertaken by the amateur should proceed cautiously and any proposed techniques that have been perfected on worthless items tested on an unimportant area first, bearing in mind what was said at the beginning of the chapter that every print presents different problems, no matter how experienced one is.

The two greatest enemies of prints are light and damp. Prints, in fact any works of art on paper, are extremely sensitive to the effects of bright light for two reasons: (a) due to the tendering effect bright light may have on the paper itself, and (b) the fading

159

effect on inks and colours, which even if of a tolerable level may not be uniform over the whole print, leaving some areas more affected than others. For these reasons display areas for prints must be carefully chosen and illuminated (see Introduction). Damp is a contributing factor in the encouragement of mould growth which can stain and weaken the paper and mar the appearance of the print. A simple precaution against the effects of damp (although not foolproof) is to impregnate any paper that is to come in contact with the print with fungicide. This may be tissue paper that is to be used in the storage of prints or a sheet of blotting paper behind any mounts for display. This is easily done by passing rolls or sheets of paper through a 10% aqueous solution (i.e. 100 ml per litre) of sodium salt of pentachlorophenol, or Santobrite as it is known, in good ventilation. When thoroughly dried and carefully aired, the paper can be used in conjunction with prints. Having said this any prints, whether on display or in storage, should be regularly and meticulously inspected, as this is the only sure way the collector has of safeguarding the objects in his care.

There is little special equipment needed for restoring prints, but a supply of good-quality blotting paper is essential. So too are pairs of various sizes of plate glass, always larger that the prints to be worked on. These will be used as a general working surface on which the print is laid, or as a support during washing or a press during drying. It is essential that all the edges are bevelled to avoid what could be serious cuts, and this can be done either by machine when the glass is supplied, or by rubbing down with wet or dry paper. If the print is to be washed, a shallow or flat dish will be required. This can be either of porcelain or plastic and is easily obtainable from photographic suppliers. Pet stores often stock similar (and much cheaper) trays for the 'convenience' of the household cat. If the print to be washed is larger than any available dish, one can easily be improvised as suggested in the chapter on Textiles.

It is important that the print is carefully examined and the following questions answered before any work can proceed.

(1) Is the paper itself in good condition? Is it soft, spongy (as is often the case with oriental prints) and limp, or is it brittle and stiff? If it is the latter, is this due to the presence of size, which can be ascertained by carefully moistening a corner with a tiny brush?

(2) Does the print have any holes, creases or tears?

(3) Is there any mildew, foxing or staining?

(4) Is the print coloured, or has a black and white part been tinted?

(5) Is the print mounted or backed in any way, or are there traces of it having been mounted or backed at any time?

Removing Old Backing

In all cases any backing must always be removed from the print, never the print from the backing. Old cardboard backing can usually be removed by covering a sheet of glass with clean blotting paper and laying the print face downwards on to this. As cardboard is usually made up of different layers, after careful examination these can be peeled away as the print lies flat. By using the steam from a kettle to moisten these layers, and taking care not to put any strain on the print, the remaining layers can usually be peeled away. If there is any difficulty more steam is applied. It is important to remove all traces of the old backing and adhesive with a soft sponge that has been slightly dampened, or the paper could become distorted. The print is then laid flat to dry between fresh blotting paper and two sheets of glass, taking care that there are no cockles or creases.

When a print has been stuck on to a paper backing steaming will probably not be sufficient. It will have to be laid, face down, on to blotting paper and glass and the backing carefully dampened with warm water on a sponge. If this is not sufficient to soften the adhesive, the print is turned on to glass, face downwards, and floated in warm water until the backing can be lifted and the print dried as above. Removing paper backing by any means, other than steaming, can be applied only where a print is suitable for washing (see below).

Cleaning

Old prints can often be improved by careful surface cleaning with a very soft artists' putty rubber, taking care not to break away the surface of the paper and testing a small corner first. Equally, much engrained dirt can be removed by careful rubbing with a small piece of day-old white bread in a circular motion, replacing the bread as it becomes dirty. The back as well as the front should also be cleaned. Any mould growths should be gently brushed from the surface with a soft artists' brush.

Washing

Washing can be carried out on untinted prints only where the paper is basically strong and not too spongy. A tiny corner area should always be tested first, before it is decided to immerse the whole print.

Once paper is wet it becomes vulnerable and can very easily tear. It must be supported either on plate glass or a piece of heavy polythene sheeting, although glass is safer until a certain knowledge of paper and dexterity is achieved. Soaking the print, supported on glass, in a bath of cold and then hot water will probably do much to freshen it up, but if particularly dirty a 1% warm solution of Synperonic NDP, i.e. 10 ml to 1 litre of warm water, will be of help. After washing, the print must be most thoroughly rinsed to remove all traces of detergent. It is then lifted out of the water, supported as always, and another piece of glass placed on top. The 'sandwich' is then turned over in order to have the print lying face downwards and absolutely flat on the glass. The print is then gently mopped with blotting paper to remove excess moisture and left to dry naturally in good ventilation.

Removal of Creases

If, after washing, the print is absolutely flat and adhering to the glass, it should in fact dry without creases, due to the contraction of the paper on drying against the tension of the glass. The same principle can be applied for correcting creases in prints that have not been washed. Laid face downwards on to glass the back is

dampened. Strips of fine tissue paper are then attached to the four sides of the print with starch paste, in such a way that 75% of the strip adheres to the glass and 25% to the back of the print. The print is then allowed to dry and then carefully released by removing the tissue as described above. It is important that the paper used to hold down the print is finer than that of the print or tearing could take place as the print dries and contracts.

The paste used in all paper restoration can be simply made up as follows, although it has a short shelf life and should be freshly made as needed.

100 g wheat starch or flour
500 ml water

Slowly stir the starch into the water in a heavy saucepan or double boiler. Boil for about 20 minutes until thickened and of a uniform consistency. Strain through a fine sieve and cool. A few drops of oil of cloves can be added as a preservative. Store in an air-tight jar and pour into paste dish and thin with water as required.

Sizing

If, after washing, the paper is in need of strengthening this can be achieved by sizing with a solution of gelatine, i.e. 1·5 grams dissolved in 1 litre of water. This is applied either with a paint brush to the back of the print while it is lying face downwards on glass or if necessary totally immersed in a bath of gelatine solution.

Bleaching

Where stains are present that have not responded to washing, bleaching may be necessary. It is, however, important to practise the methods described below on worthless items in order to assess their effectiveness, always testing each individual print before carrying out the work.

A bleaching agent known commercially as Chloramine T is highly recommended to the amateur, for its action is gentle and can be used either locally or for overall immersion and its bleaching power is quickly used, leaving no harmful residue on the

paper, making rinsing unnecessary. It is particularly useful when applied locally to stains on prints that have been coloured, making immersion inadvisable.

Unfortunately Chloramine T is rather unstable and so the fine white powder must be well sealed and carefully stored. It is made up just before it is needed by dissolving 2 grams of powder in 100 ml of water. This solution is then applied locally to the stain with a fine artists' brush with the print lying face uppermost on a glass sheet. After about an hour the area is dabbed with blotting paper and inspected. As Chloramine T is gentle in action, the process will probably have to be repeated several times before the stain is reduced.

A much more drastic bleaching agent, not without its hazards, is sodium hypochlorite. Made up into a solution of one volume of sodium hypochlorite to twenty volumes of water, it will remove most stains. However, if immersion is continued longer than absolutely necessary the paper will become a stark white and be considerably weakened. This bleaching agent will also remove any writing on the print. If this is not to be removed it must be protected by a 5% solution of nitrocellulose, i.e. celluloid cuttings dissolved in equal volumes of the solvents acetone and amyl acetate, painted over the writing and allowed to dry before bleaching. After bleaching it is removed by passing it through a bath of acetone.

As sodium hypochlorite is alkaline in action this tends to soften the paper, and so ideally another bath containing dilute hydrochloric acid (a dangerous chemical) of about $\frac{1}{2}$%, i.e. approx 5 ml to approx. 1 litre of water, should be at hand. Rubber gloves should be worn and there should be good ventilation and access to running water for dousing the skin in case of accidents when preparing the solution. Alternatively the print can be removed on the support from the bleaching bath, and flooded with the dilute acid solution from time to time, then returning it to the bleaching solution.

Supported as always, the print is allowed to remain in the bleaching solution only until the stains begin to disappear, and

before the paper has taken on a stark whiteness. It is then passed through a bath of 2%, i.e. 20 ml per litre, of photographic hypo (sodium thiosulphate) in order to remove the chloride left behind by this form of bleaching, and washed for some time under gentle running water. Still on its support it is then dried as above.

Removal of Stains

Candle grease and wax As much hardened wax as possible should be removed with a blade. Some, but not all, of the wax can be removed by covering the print with blotting paper and gently ironing the area so that the wax melts and is absorbed by the blotting paper. To remove the wax completely the print must be supported on glass and immersed in a bath of petrol (gasoline), and the stain gently dabbed with a brush until it disappears.

Fat and oil stains These are generally difficult to deal with. Benzene may be effective, but great care must be exercised as it is highly volatile. Pyridine in its purest form is more effective especially for old stains. It may also be used for tar and asphaltic marks. Application in each case should be local.

Tea and coffee Ever since the introduction of these beverages, paper documents including prints have been under their threat, especially items from the library. Garments and table cloths were also prone to staining by the occasional upset and spillage. Unfortunately the older the stain the more difficult it is to remove. After dampening the area of the stain, a 2% aqueous solution of potassium perborate must be applied and left while the print is exposed to sunlight for between 45 and 60 minutes. Care must be taken, for although the solution has only a slow bleaching action, it is an alkaline and can attack the paper. If by accident the paper is softened the process can be stopped by flooding with water. After treatment the print must be allowed to dry thoroughly. The print may be finished by bleaching with ethereal hydrogen peroxide. Before describing this process it must be emphasised that *it is dangerous* and should be carried out only in

a well-ventilated room, preferably the garage or outhouse. No naked lights or flames of any description must be present (including cigarettes) as ethereal hydrogen peroxide is highly inflammable. In view of this, most readers may feel that it is best left alone—indeed this is my recommendation. A substitute bleaching as described earlier may be satisfactory. If you decide to proceed, the process is carried out in the following way.

Ether is mixed in equal parts with hydrogen peroxide and shaken in a glass-stopped bottle. The two liquids are immiscible, separating into water with impurities at the bottom and ether with hydrogen peroxide at the top.

Bleaching is carried out by means of a cotton-wool ball on the end of a 15 mm glass tube. This is saturated in the *top layer of the solution only* and is applied to the stained area by dabbing. *Be careful—ether may send you to sleep.*

Ink stains Ink stains are probably the most common stains found on paper. They are not easy to remove owing to the fact that there are so many different kinds of inks, both iron-gall and modern. The methods used are therefore numerous and only trial and error will succeed, unless of course you happen to have a fully equipped analytical laboratory.

A 2% aqueous solution of Chloramine T may prove effective and should be tried first. It should be freshly made up and brushed on the offending area. A 10% solution of citric acid or a 5% solution of oxalic acid may also work. Always carry out bleaching carefully making sure that it does not go too far. Stop just before bleaching is complete. The print must then be washed thoroughly. If this still does not work, a stronger bleach like formaldehyde sulphoxylate, applied as a powder on to the dampened stain, may do the trick. Always take care whatever chemical you may use and wash the print thoroughly afterwards.

Repairing Tears in Paper
Provided the print is strong enough and there are no complications such as tinting, the best time to repair tears in paper is after

they have been immersed in water, are face down on a sheet of glass and half dry. Using the back of a clean spoon the two edges of the tear are gently worked back together, taking care not to further damage the delicate damp paper or cause it to tear. Once the quality of the join has been determined a little starch paste (detailed above) can be applied to the tear from the back of the print with a very fine brush, taking care not to introduce too much paste, particularly to the front of the print. After wiping away all excess paste the print can be covered with blotting paper and sandwiched beneath another sheet of glass to dry.

In the case of a cut, rather than a tear, where the edges are sharp, these will need gentle chamfering with a tiny piece of very fine wet or dry paper before the edges are welded together as above.

If a patch is required to hold a torn edge together, for example on an oriental scroll or where the tear will be under strain, it is important that the grain of the paper patch is following the same direction as that of the print. The patch must be of paper that is lighter than the original, tissue is particularly useful, sparingly pasted with slightly dry paste and just large enough to cover the tear. The pasted patch must be laid absolutely flat, with no creases or air bubbles. This is achieved by holding the patch in such a way that one edge is in position, just touching the print. The patch is then slowly and systematically lowered and smoothed completely flat with the aid of a swab of cotton wool.

Much experience in repairing paper can be gained by experimentation on worthless items as well as a knowledge of the way paper responds under different conditions and a certain dexterity which is essential for this type of work.

12 *Books*

Most people find at some time or other that their favourite book, be it extremely old or comparatively new, has deteriorated and is the worse for wear. This may be due to bad storage, bad binding material, bad handling or quite simply to excessive use—above and beyond the endurance of the binding. Without question the best course of action would be to have the volume rebound professionally, if you can (a) find a bookbinder, (b) afford the cost and that the book justifies it, and (c) are prepared to wait months or even a year for the job to be completed. You may feel that because of any one or all of these factors this is not possible, or you may even wish to retain the original appearance of the book (of course this is possible professionally but will be expensive). What should you do? Do not despair, it is possible to apply first-aid treatment to your book, but you must not expect the result as efficient as a rebind. In no case should you subject a rare and valuable book to your skills no matter how confident you may feel—the only sensible thing to do with any book in this category is to save it until such time as you can get a bookbinder to deal with it properly.

Before proceeding further we should ask ourselves just what is a book? Silly question, you may answer, surely everyone knows what a book is. True, it may be difficult to find someone who does not know what a book is—superficially. What is more important is to consider in depth what a book *is*. First, it is organic, i.e. that it is composed principally of vegetable or animal products. Physically it is a number of paper sheets held together in

a fixed order between boards. Books may be divided into pages, boards (covers) and spine. The pages may have been printed separately, or in groups known as sections. Depending on the size of the book, the paper and the size of the printing machine, the sections may be of 4, 8, 16 or 32 or even more pages. These are folded, sewn, collated into a running order, and then sewn together down the folded edge which is known as the spine. The edges of the book, top, bottom and fore-edge are trimmed by guillotine to form individual pages. In some books the edges are rough hand slit or deckle-edged and are uneven. In others the edges may be stained with colour or gilded. The pages that are pasted on to the boards and precede and end the book are known as endpapers. The folded spine edge is gummed and reinforced with scrim which overlaps the boards.

Books are similar whether they have been produced by machine or by hand. This book, for instance, is made of several printed sections of text within which has been sandwiched a 64-page section of colour illustrations. These colour illustrations were printed on both sides of a single sheet of paper. Some books old and new have illustrations 'tipped in', i.e. glued in separately. Sometimes these fall out.

Bindings tend to be of a number of kinds—full leather, half leather, full or half cloth or combinations of these. Leather bindings generally are either morocco (goatskin) or calf. Calf leather is more susceptible to damage. Cloth bindings include linen, buckram or today's synthetic products. Some 19th century and early 20th century books have paper-covered bindings including marbled papers. The adhesive used in all old books is animal glue.

What happens to a book to cause it to deteriorate and to fall apart? The answer is not that simple, as a number of factors are involved. Deterioration can be due to atmospheric, mechanical or inherent chemical defects. Atmospheric deterioration mainly arises through bad storage. Books are affected by dust, dirt, damp, temperature, humidity, sunlight, let alone atmospheric pollution from modern industry.

Paper is hygroscopic and therefore is susceptible to excess humidity as is leather. On the other hand if the atmosphere is too dry, the binding could dry out and crumble. When industrial pollution, with its concentration of sulphur dioxide and sulphur trioxide, comes in contact with damp, the latter forms sulphuric acid, the reaction of this on a book needs little imagination. Damp and excessive humidity also allows mildew and fungi to develop and invites book-eating insects such as silver-fish.

Dirt and dust are also an invitation to insects that are attracted both to feed on paper and leather as well as the glue. Book lice, although alarming in appearance, are harmless as they feed on mould.

Books must be kept in a balanced humidity and temperature, and not exposed to direct sunlight which has a drastic and harmful effect on them. They must have good air circulation and be kept clean. Do not keep them in closed bookcases—this does not help, and may even hinder, especially if the air within becomes stagnant.

Healthy books are handled. Perhaps the best word would be fondled—meaning handled lovingly. This keeps the pages aired and the bindings supple, thus protecting against insects and deterioration.

Handling, surprisingly, can also be the book's worst enemy, for very few people really know how to handle a book. Treat it as a fragile friend. Both old and new books need correct handling. Some people don't just open a book, they attack it! A book is made of fragile and perishable materials and deserves respect. Always cradle the spine of a book in the palm of your hand, either the right or left, depending whether you are right or left handed. Open it gently—never lie it down flat and press the two sides downward as this causes severe strain on the stitching and the spine. Colour plate 32 shows the best method of handling. Bad handling will cause weak spines, loose boards and loose sections of paper.

The third factor in the deterioration of books is inborn. In some cases the leather used for binding books was not correctly cured and acid (used in the curing process) was not washed out. This

causes chemical deterioration which can be detected as crumbling edges and weak hinges.

Leather bindings suffer from mechanical and atmospheric deterioration but unlike chemical deterioration this can be controlled and rectified. They can be cleaned and preserved.

Leather bindings can be cleaned by washing with pure soap and the very minimum of water. This is applied with a cotton-wool swab or a very soft brush. *Never, never* clean a binding that has begun to peel or has split. Another method includes swabbing with turpentine after having carefully tested the leather to ensure that the dye is fast and will not be removed by the turps. The same advice must be emphasised in stains. These may be (if necessary) removed by gently rubbing with a cotton-wool swab or cotton-wool sticks dipped in petrol (gasoline) or white spirit. An alternative method, effective in removing grease and wax stains, is to first scrape away as much as possible, then place several layers of clean white blotting paper over the stain and iron with a domestic iron set at the lowest temperature. Gentle pressure should be used. The blotting paper should be left to dry for about thirty seconds and then removed. The process should be repeated until all the stain that can be removed is removed. Non-grease stains may sometimes be removed by a mixture of water and white spirit on the swab. All treatments need the utmost care.

Old leather bindings lose their lubricants. These can be replaced by treating with commercial leather preservatives or preferably with British Museum Leather dressing, the formula for which is given in the Formulae at the back of the book. The dressing is applied *sparingly* with a cotton-wool swab and gently rubbed into the leather. The book is then left to dry for twenty-four hours after which the excess dressing is wiped off and the leather softly polished. The result can be quite startling and most impressive, as the dressing not only restores the surfaces and colour, but brings up any gilt work that may be there.

All of these treatments may sometimes be too late. The book may have a loose or detached spine, broken cover or bands; pages may be torn, stained or foxed. In the case of the latter three faults,

the reader is advised to refer to the chapter on Prints, for the treatment is the same.

In the case of a loose or detached spine, the following first-aid repair will prove effective. First take an old toothbrush and brush all the old animal glue from the scrim. When this has been done paint on a thin layer of PVA emulsion adhesive (water-based) and let it dry. Preferably accelerate the drying time by blowing warm air from a hairdryer. Repeat the process several times making sure that the adhesive penetrates between the scrim binding the sections and the sewing to the scrim. Eventually a layer will have built up over the scrim. At this stage apply another layer, then carefully replace the spine; wrap and tie into position (see plate 32). Place somewhere warm (not hot) and dry and leave for several days to dry. When removed from its wrapping, the book should be really strong. The process may also be used for books where the sewing has become very weak.

Loose boards may be replaced by carefully removing the endpapers, then making a hinge scrim on to the spine using the same gluing technique as described above. When dry, new endpapers can be cut to shape and applied, again using the same adhesive.

Broken covers may be reconstructed by first cutting away loose board and binding the area with new cardboard cut to the same size and thickness. Use PVA as above. When the correct shape has been achieved the repair can be covered with leather or similar material in the manner illustrated in plate 32. It will be necessary to gently prise the endpapers up from the cover to allow the new binding cloth or leather to be folded under. To produce a pleasing book it will be necessary to cover all four corners.

Remember, with books as with many other kinds of antiques, the best treatment is prevention, so look after them well.

Appendices

Acetic acid
Acetone
Alcohol (surgical spirit)
Almond oil
Ammonia★
Amyl acetate★
Beeswax
Benzene★
Calgon
Carbon disulphide★
Carbon tetrachloride
Caustic soda★
Cedarwood oil
Chloramine T
Citric acid
Ether★
Ethylene dichloride★

Formaldehyde (Formaline)
Formaldehyde sulphoxylate
Gelatine
Glycerine
Hexane★
Hydrochloric acid★
Hydrogen peroxide★
Ion exchange resin
Kaolin
Kerosine (paraffin)
Lanolin (anhydrous)
Linseed oil
Methylated spirit
Nitric acid★
Nitrocellulose
Oxalic acid

Paraffin
Petrol
Polyurethane
Polyvinyl acetate
Polyvinyl alcohol
Potassium perborate
Pyridine
Saponaria
Silica gel†
Silver nitrate
Sodium carbonate
Sodium hexameta-phosphate
Sodium hypoch-lorite
Sodium sesquicar-bonate
Sodium thiosul-phate
Titanium dioxide
Zinc powder

★ Dangerous. Handle with care.

† Useful and very effective drying agent which does not become moist or cause staining. Changes colour to pink when it is no longer able to absorb moisture. Can be re-activated by heating in oven, when it will regain its original blue colour. This process can be repeated indefinitely.

Most of the chemicals and substances mentioned above are available from museum or laboratory chemical suppliers (see Telephone Yellow Pages for addresses). Some, if not all, may also be available from pharmacists.

Araldite (AY 103)	Epoxy resin. A clear, plasticised liquid. There are a number of varieties of epoxy resins which differ from country to country. Always enquire from manufacturer or supplier for equivalent of the variety quoted in text. A two tube variety is readily available commercially but is not the same grade as that quoted in text which is available from museum laboratory suppliers.
BASF Wax A	Polythene wax.
Calgon	Sodium hexametaphosphate. Used in removing calcareous deposits from bronzes.
Chloramine T	A mild bleaching agent. Available commercially as a white powder.
Cosmolloid Wax 80	Microcrystalline paraffin (kerosine) wax.
Durofix	Clear adhesive—substitute can be made by dissolving Perspex (acrylic) in 5 ml glacial acetic acid and 195 ml of ethylene dichloride. Can be removed with acetone.
Ercalene	A lacquer used for coating silver, brass, copper, bronze and pewter, etc.
Evo-Stick Resin W	A polyvinyl acetate emulsion adhesive marketed for woodworking but which can be useful in some of the processes described in the book. There are a number of varieties of PVA emulsion adhesives marketed commercially under different names in various parts of the world.

Flex-i-grit	A very fine highly flexible abrasive on Mylar film (not paper) used in porcelain repairs and retouching.
Gipgloss Cellulose Thinner	A cellulose thinner and solvent for Polyurethane PU11.
Gold Leaf Transfer	Sheets of gold leaf with acid-free tissue backing.
Gold Tablet	Gold powder held in water-soluble gum. Used for retouching gilding on porcelain.
Jenolite	A proprietary rust remover.
Lissapol NDP	Old name for Synperonic NDP. See under Synperonic.
Matting Agents TK 800 HK 125	Matting agents.
Milton	Bleach. Sodium hypochlorite solution.
Nitromors	Non-inflamable paint stripper based on methylene chloride. Use only water-soluble variety. Degreasing agent.
Paralac	Stoving enamel. Used in porcelain restoration but not recommended for the amateur.
Perhydrol	Hydrogen peroxide 100 vols.
Perspex	A clear (or coloured) Acrylic available in sheets or rods. Also known as Plexiglass.
Petrol	Petroleum spirit—gasoline.
Plasticine	A non-toxic modelling material which does not harden when exposed to air thereby enabling it to be used many times.
Plus Gas Fluid A	A rust softener and inhibitor.
Polyfilla	A vinyl reinforced cellulose filling compound. Available as a paste or powder which can be mixed with water and has minimal shrinkage on drying. A

number of filling compounds are available commercially; care must be taken to ensure that the filler chosen is compatible in hardness to that which it replaces.

Polyurethane PU11 Atmospheric moisture curing polyurethane, which is easy to use and virtually non-discolouring.

Pyridine Solvent, used for removing stains of oil, fat and tar.

Santobrite A non-volatile fungicide. Derivative of pentachlorophenol.

Saponaria A cleansing agent. Natural occurring substance widely found in the higher plants. May be made by infusing Saponaria (Soapwort) or by dissolving commercially available powder.

Sepiolite Hydrated magnesium silicate used for drawing out stains in porcelain and stone. Use 100 mesh.

Silver Dip An electro-chemical liquid silver cleaner. May also be used for other metals but the same liquid *must never* be used for more than one metal.

Solvol Autosol A special non-scratching chrome polish paste used for finely polishing retouching on porcelain and removing blemishes from the surface of some stone sculpture. Made in West Germany.

Synperonic NDP Detergent. Non-ionic wetting agent. Use only pure—not commercial liquids based on it. U.S. equivalent Igepal— CA Extra.

Terylene net A man-made fibre net recommended as a substitute for Nylon Monofilament Screening (filtration fabric).

Winton Matt Varnish	A commercial artists' varnish consisting of a mixture of wax and resin.
Vinamold Moulding	Hot-melt compound (MP 130–150 °C) of medium flexibility. Can be re-melted for further use. Used in plates 6 and 7.

DANGEROUS CHEMICALS

The following chemicals are potentially dangerous and great care is needed when handling them.

Acids

Concentrated sulphuric acid—causes burns to skin and organic substances. Dilute solutions of the acid must always be prepared by adding acid to water, slowly, stirring constantly. *Never add water to acid.*

Concentrated nitric acid—strongly corrosive, causes burns and stains skin a deep yellow. Dilute by adding acid to water.

Concentrated hydrochloric acid—causes burns. Care must be taken when opening container to ensure fumes do not come in contact with the eyes.

Alkalis

Caustic soda—as name suggests it is highly caustic. Do not let solid come into contact with skin. When preparing solutions, use only a porcelain, iron or stainless steel vessel standing in a large bowl or sink and add the solid to the water *slowly and carefully*. Great heat is given off in this operation, hence it is not advisable to use a glass vessel which may crack.

Concentrated ammonia—bottles should always be kept cool—never keep in the sun. As it may vaporise in the bottle care must be taken when opening to ensure that the stopper does not pop out due to pressure.

Hydrogen peroxide—the same precautions as for ammonia must be observed. This chemical is available commercially in a number of strengths.

100 vols—sometimes called Perhydrol (approx. 30% w/v
 hydrogen peroxide)
 20 vols—approx. 6% w/v hydrogen peroxide
 10 vols—approx. 3%

Store all solutions in coloured bottles away from light and heat.

Inflammables

Fire precautions must be taken with all inflammables which includes gasoline (petrol), benzene, hexane, etc.

Special notes

Carbon disulphide (BP 46 °C). This is a highly volatile and poisonous liquid. *Explosive* when mixed with air.

Diethyl ether (BP 34·6 °C). Highly inflammable and volatile. *Explosive* when mixed with air.

N.B. *Always ensure that a foam fire extinguisher is close at hand whenever using carbon disulphide or diethyl ether.*

FIRST AID

In the event of burns with either acid or alkalis flood the contaminated area with water. *Then*

For Acids—Wash with a dilute solution of sodium bicarbonate
 or

For Alkalis—wash with vinegar or a *very dilute* acid

SOME ADHESIVES AND THEIR USES

Animal glue	Not waterproof. Made from material such as bones etc. Scotch Glue—must be applied hot, sets as it cools. Cold setting variety allows more time to be taken in application. Joints must be held together for a long time while glue is bonding. Superseded by synthetic wood glues.
Contact adhesive (synthetic rubber & resin)	Synthetic rubber and resin adhesive which must be applied to both surfaces and allowed to dry before they are brought together. Not suitable for furniture joints. Has disadvantage that surfaces once brought together cannot be adjusted into position. A water-base variety is available.
Cyanoacrylate	'Instant' adhesive. Vinyl monomer-base. Sticks most non-absorbent materials in seconds. Most objects can be handled after 2 minutes. Dangerous—if it touches fingers, difficult to get off. Should be used thinly.
Epoxy resin	Resin uses hardener which is mixed in various proportions. Hardens by chemical reaction which can be accelerated by gentle heating. Some varieties will only cure by heating. Can be mixed with colourant and used as a filler on porcelain. Excellent adhesive for porcelain.
General purpose	These adhesives, based on nitrate

179

	and polyurethane rubbers are generally known as household adhesives. Stick most materials but generally not recommended for repairs of antiques.
Polyester resin	A quick-setting adhesive (sets in 10 minutes); can be useful for repairing stone and earthenware but discolours.
Polystyrene cement	A composition of polystyrene dissolved in solvent. Fuses plastics. Not recommended for any antique repairs.
Polyvinyl acetate (PVA) emulsion	A white liquid—useful to repair less expensive furniture where animal glue is not readily available. Joints must be cramped. Also mends pottery; can be used to repair books. Soluble in water or acetone. Must not be subjected to frost.
PVC	A combination of plastics and resins in a solvent. Generally not of use for restoration.
Rubber-base adhesive	A suspension of minute particles of rubber. Flexible bonds—used on some fabrics, carpets, etc.
Starch paste	Natural adhesive produced from wheat or similar material (see Formulae). Suitable for books, prints, paintings, etc. Short shelf life of 1–3 days.
Synthetic resin	Resin and hardeners which are mixed together. Joints have to be cramped. Only suitable for wood, but not recommended for antiques.

In all cases, manufacturer's instructions must be followed

Formulae

Beeswax Polish
Suitable for wood, leather and some iron and steel.

Beeswax	28 grams (1 oz)	
Turpentine	85 ml	(3 fluid oz)

The beeswax is melted in a saucepan or tin and when liquid, turpentine is stirred in taking precautions against possible fire hazards. When fully dissolved, allow to cool. The resultant wax will be yellow; if a lighter colour is required purified white beeswax should be used.

British Museum Leather Dressing
Excellent preservative and restorer for leather—must be used sparingly.

Anhydrous Lanolin	200 grams (7 oz)
Cedarwood Oil	30 ml (1 fluid oz)
Beeswax	15 grams ($\frac{1}{2}$ oz)
Hexane (or Petroleum Ether BP 60–80 °C)	330 ml (11 fluid oz)

As the mixture is highly inflammable care must be taken to ensure that no naked light is in the vicinity or in the room (this includes

cigarettes!) during its making or application. After application to the leather (sparingly) it should be left two days before polishing the surface of the leather with a soft cloth.

Method Shreds of beeswax are mixed with the hexane and shaken until dissolved. Lanolin is then added followed by the cedarwood oil.

Microcrystalline Polishing Wax

There are two types—the solvent type and the emulsion type. The latter is most suitable for coating antiquities and works of art. Several kinds of microcrystalline and polythene waxes are available each of which gives a different gloss which can further be varied by the proportions of the waxes used.

Basic type

Cosmolloid Wax 80 (hard)	100 grams
B.A.S.F. Wax A	25 grams
White Spirit	300 ml

The waxes are cut into small pieces and then melted together. When liquid and fully mixed they are poured quickly into the white spirit. While the mixture is cooling it must be stirred constantly so that a suitable consistency is obtained. Store in screw-top jars. *Fire precautions must be taken when mixing.*

A matt wax can be produced by using 10 grams Cosmolloid Soft Wax with 100 grams B.A.S.F. Wax.

Mixture for Cleaning Dirty Furniture

Turpentine	1 part
Vinegar	1 part
Linseed Oil	1 part
Methylated Spirit	$\frac{1}{4}$ part

All ingredients are poured into a bottle and shaken well before use.

Starch Paste

The paste used in all paper restoration can be simply made up as follows, although it has a short shelf life and should be freshly made as needed.

100 g wheat starch or flour
500 ml water

Slowly stir the starch into the water in a heavy saucepan or double boiler. Boil for about 20 minutes until thickened and of a uniform consistency. Strain through a fine sieve and cool. A few drops of oil of cloves can be added as a preservative. Store in an airtight jar and pour into a paste dish and thin with water as required.

Index of processes illustrated in colour plates

Index